# THE BEGINNER'S GUIDE TO
# Underwater Digital Photography

Larry Gates

AMHERST MEDIA, INC. ■ BUFFALO, NY

**Check out Amherst Media's blogs at:** http://portrait-photographer.blogspot.com/
http://weddingphotographer-amherstmedia.blogspot.com/

All photographs by the author unless otherwise noted.

Published by:
Amherst Media, Inc.
P.O. Box 586
Buffalo, N.Y. 14226
Fax: 716-874-4508
www.AmherstMedia.com

Publisher: Craig Alesse
Senior Editor/Production Manager: Michelle Perkins
Assistant Editor: Barbara A. Lynch-Johnt
Editorial Assistance from: Sally Jarzab, John S. Loder, Carey Anne Maines

ISBN-13: 978-1-58428-274-7
Library of Congress Control Number: 2009903900
Printed in Korea.
10 9 8 7 6 5 4 3 2 1

# TABLE OF CONTENTS

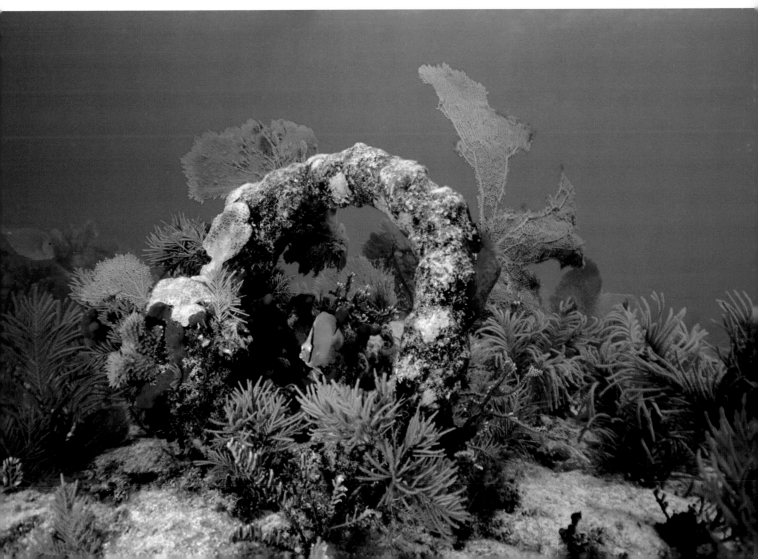

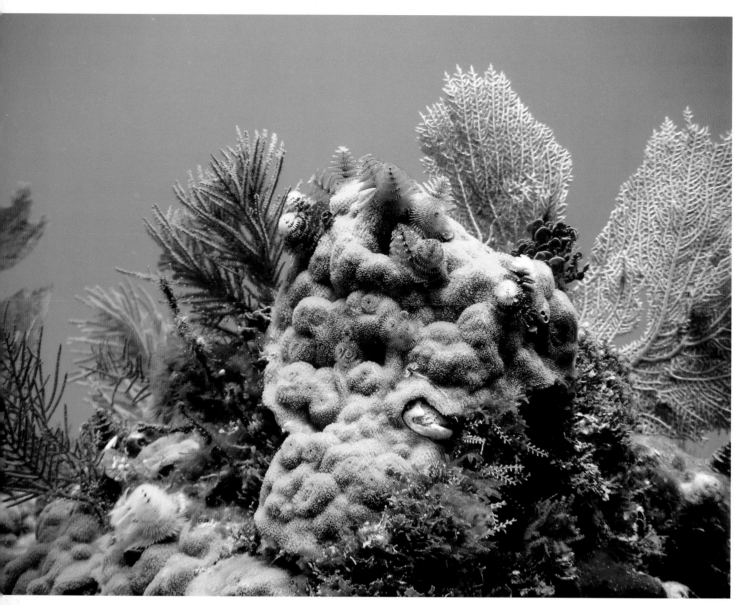

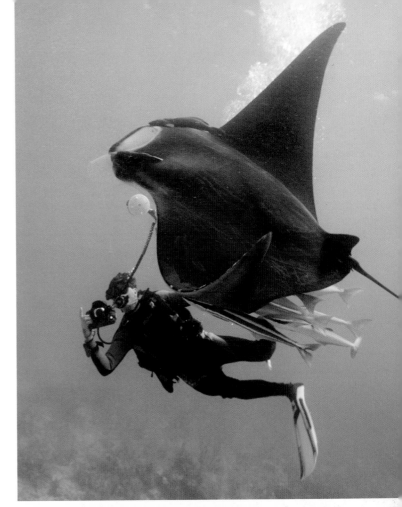

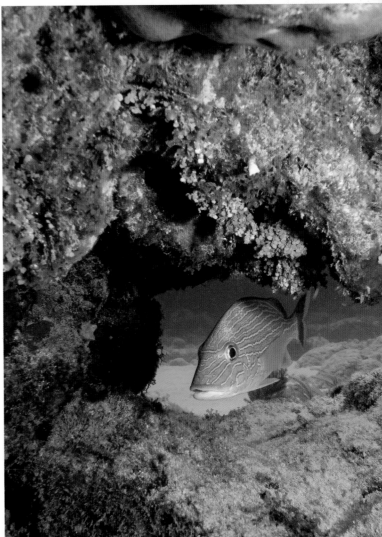

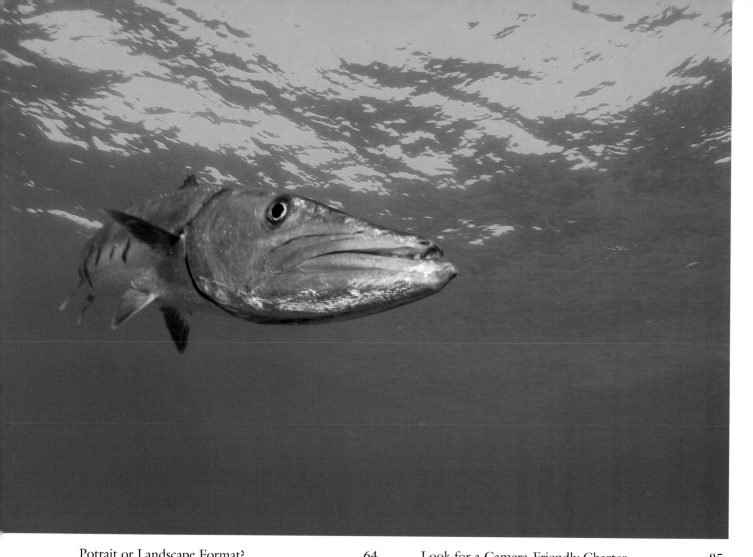

# THANK YOU

A big thank you goes out to the following individuals: Mike Hall, Tom Bowers, Matt Emery, Al Malone, Mike Waters, Mike Hewitt, Scott Rodman, Liz Johnson, Stephen Frink, Battle Vaughn, Matt Landau, Hans DeJager, Greg Stuart, Bill and Karen Snyder, Brian Bolten, Steve and Jennifer Wallace, Barry Carter, Shelly Bledsoe, Connie Boynton, Kate Hummel, Chris Edson, Joe Lavery, Jackie and Maggie Goering, Lisa James, Kelly Rabe, Capt. Tom Scott, Sasha Bollanger, Tom and Therisa Stack, Jan and Don McGarva, Craig Napier, Frank Vertosick, John and Marla Mitvalsky, Dan Mechelke, Robert McCann, Rich Ross, Vickie Pelletier, Karen Minshew, Loriele Inman, Jim Wentz, Kara Leahy, Steve Minor, Brendan Heggman, Laurie Gates, Norma and Aubrey Wolff, Dick Rutkowski, Joe Clark, Doc Schwenler, Cynthia Fuentes, Harry Keitz Jr., Jim Bates, Joe Thomas, Mary Moyer, Sonia Murray, Ryan Canon, Bridget Palmer, Jennifer Maksymiak, Aja Vickers, and Scott Stackal.

# ACKNOWLEDGMENTS

I am grateful for the help and support that the following businesses have provided to me over the years:

Ocean Divers, Key Largo, FL
Scuba-Do, Key Largo, FL
Blue Water Divers, Key Largo, FL
Pleasure Diver, Key Largo, FL
South Beach Divers, Miami Beach, FL

The goal of this book is to simplify a seemingly complex, complicated, technical, and reputedly difficult topic: underwater photography. My aim is to make it easier for the reader to begin taking underwater photographs or, if they have already begun, to improve their underwater photography.

## A BOOK FOR THE "REGULAR GUY"

This book was written for the "regular guy"—but please note that my use of this term is not intended to be gender-specific; this is a book for female photographers, as well.

So, who is the regular guy? The regular guy is not a professional photographer. He does not have a lot of technical knowledge about photography but is interested in obtaining enough know-how to build a foundation in underwater photography. The regular guy does not necessarily have the latest and greatest photography equipment. He is a scuba diver, from novice to expert, who thinks it's kind of cool to be able to dive and take pictures of the neat stuff he sees down below. Regular guys come from all walks of life and may be of any age.

A diver accompanies a Green Sea Turtle as it glides over the reef.

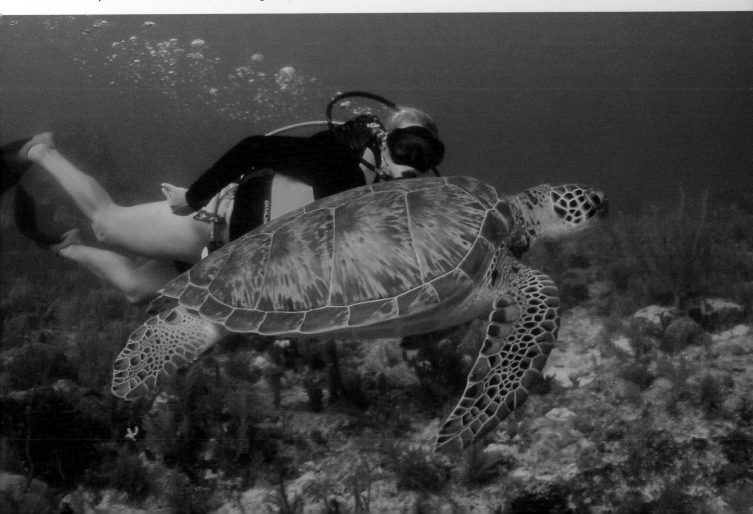

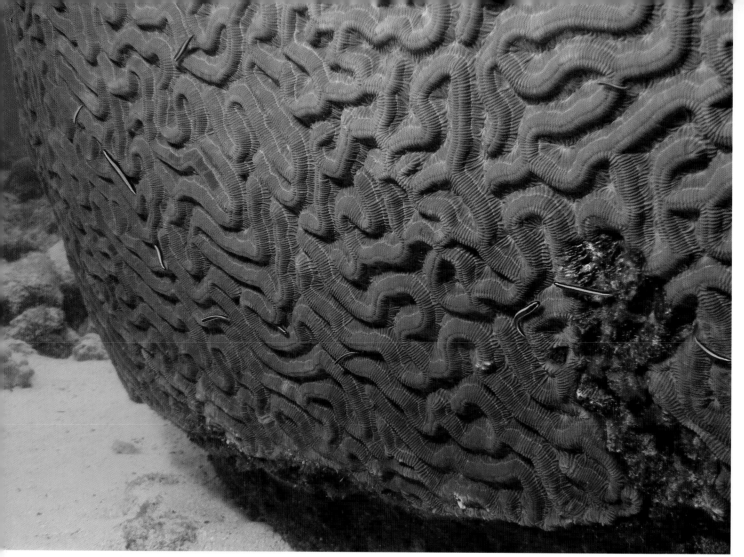

ABOVE—Cleaner gobies have set up shop, a fish-cleaning station, on a head of brain coral. FACING PAGE—A diver approaches a deep water Sea Fan growing on the side of a shipwreck.

## MY BACKGROUND

My own background in photography began with taking topside snapshots using a Brownie camera; later in life, I used a 35mm point-and-shoot camera while on vacation. I didn't take advantage of any of the photography courses offered in school.

I began doing underwater photography in 1992 after purchasing a used underwater camera. Since then, I've enjoyed a modest share of photographic kudos and successes. On a formal basis, I was a student of the Nikon School of Underwater Photography, conducted for professional-level underwater photographers and presented by Stephen Frink Photographic. I've participated in underwater photo contests and, due to ill-sighted judges, actually won one of those! I have been infrequently published in magazines such as *Skin Diver, Florida Scuba News,* and *Water Line.* I worked as a safety and support diver for Paramount Stu-

dios. I provided technical assistance to *Vogue.* I also provided services to JKP productions in Tokyo.

I've had the opportunity to hone my skills as an underwater photographer in the reservoirs of South Dakota, the Hawaiian Islands, the Cayman Islands, Cozumel, the Turks, Caicos Islands, the Bahamas, and the Florida Keys. In 1994, I became credentialed as an educator of underwater photography and have been teaching underwater photography in Key Largo ever since.

## THE LEARNING PROCESS

A psychology professor in college said that the best lesson he could teach us, his students, was how to teach ourselves. Likewise, one of my goals in this book is to help you teach yourself. The Japanese term *kaizen* is often used in the martial arts. Roughly translated, it means "being in a state of steady improvement." No matter how great a shooter

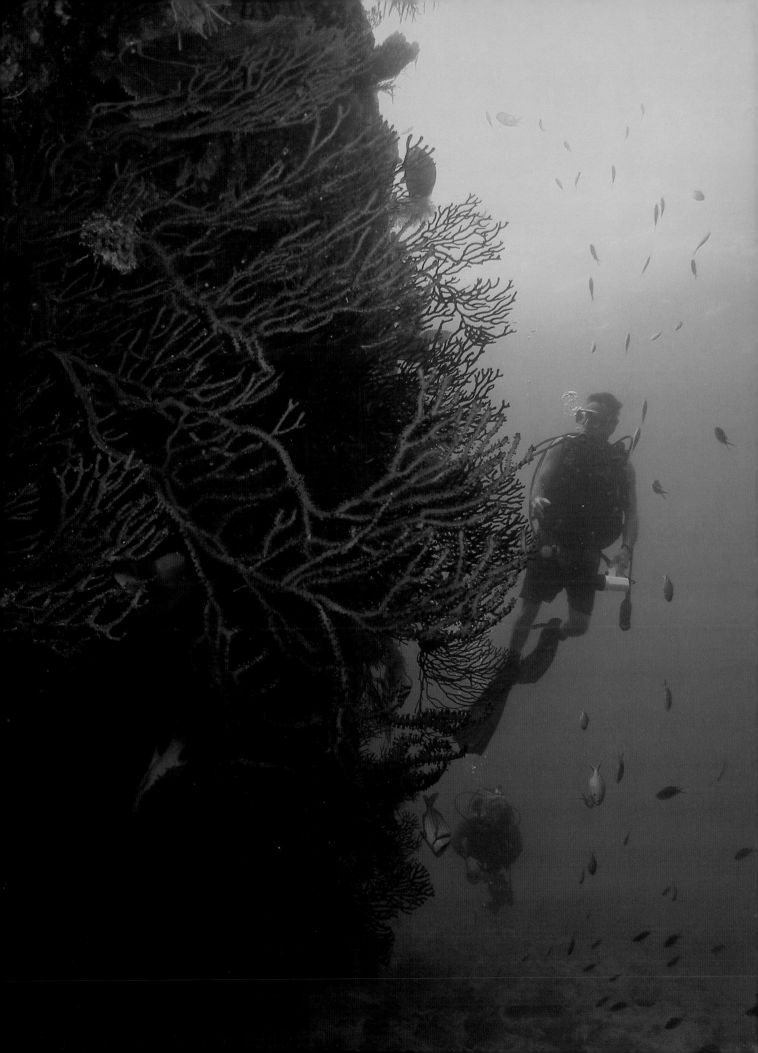

Yellowtail snapper forage for juvenile shrimp among Sargassum seaweed.

you are, you can still improve. This book will teach you how—and do it in a pretty painless way. I wrote this book with the idea that it should be fun to read. I enjoy underwater photography and believe that learning about it should also be fun.

Of course, there are some difficulties to this endeavor, but this book will identify those and give means and methods to overcome them. Essentially, rather than looking at underwater photography as being difficult, I encourage you to look at it as a fun-filled challenge. You will be taking underwater photographs for a lot longer if you do.

The mystery of underwater photography is that there is no mystery to it. Underwater photography is far simpler than one might guess. One purpose of this book is to demonstrate this. In fact, by the time you've finished read-

ing this book you should be able look at a photograph and determine how it was taken. If you can sort that out, you will likely be able to take the same type of picture.

Enjoy this book as you embark on the journey from being a picture taker to becoming an image maker!

## BECOME A SKILLED DIVER FIRST

You must become a certified scuba diver before you can become an underwater photographer. (Okay, I've just stated the obvious—I know someone out there is thinking, "But Larry, I can hold my breath for a very, very long time!" If that is the case, I will happily grant an exception to the rule.) It doesn't hurt if scuba diving is second nature to you so that you can focus on your photography. Remember, in underwater photography you are trying to do two things at once: scuba dive and take pictures. If you are having trouble with one, it follows that you will have trouble with the other.

An underwater photographer should always be aware of their limits with respect to depth, decompression status, air consumption, and navigation skills. More than one professional underwater photographer has come up "bent" as a result of staying underwater too long in pursuit of that last great image. Even a once-in-a-lifetime shot of the blackcap fairy basslet is not worth a trip to the recompression chamber, running low on (or out of) air, or risking your life. The goal of a good underwater photographer is not just to take the photograph, it's to *come back* with it!

## RESPONSIBLE DIVING

**Make a Plan.** Have a dive/photo plan and stick to it. That way, you will know what it is you want to accomplish during the dive and be able to measure how well you are progressing toward your goal. When it is time to surface, it *is,* unfortunately, time to surface! Several years ago, while ascending from a dive with a photo student, we saw a turtle cruising by at a deeper depth. My student cancelled her ascent with me, descending to the turtle's depth to try to get the shot. We were diving shallow and still had ample air

and bottom time. However, we had agreed to surface and the break in discipline was wrong. In another situation—with deeper water, less remaining bottom time, or less air—this breech of discipline could have been a truly sobering event.

**Be a Good Buddy.** On a related note, it is also important to be a good dive buddy and to be aware of the person you are diving with. Because they often get caught up in the pursuit of great images, underwater photographers have a reputation for being awful diving partners.

> Improving one's diving skills has rewards beyond improved imagery.

**Conservation Is Key.** Improving one's diving skills has rewards beyond improved imagery. We end up being better keepers of the reef. We also end up enjoying our dives more. Our air consumption improves, we are more relaxed underwater, and we physically exert ourselves less.

Underwater photographers have a bad reputation for being "crashers of coral," taking liberties by contacting the fragile coral in an effort to photograph their subject. This is a big no-no. In my class, I preach that even the village idiot can get a good picture if they are willing to crash the coral to get that shot. The trick is to get the shot without any negative impact on the marine environment. We need to be keepers and caretakers of the reef and its inhabitants. Conservation should always be a conscious part of our technique. (*Note:* Inadvertent contact with the corals happens frequently enough. If you wonder whether you may

 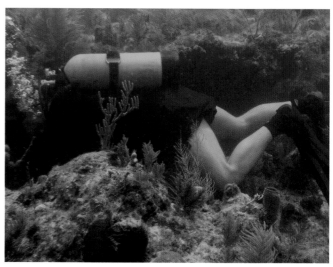

ABOVE—Here are some "coral crashers." Before crashing the coral, ask yourself whether that shot or image you are trying to take is worth killing a living thing (coral). I cannot imagine that your answer would be yes. As with everything else in scuba, you must stop, think, and then act. Figure out a different way to get that shot. If you can't, don't attempt the photograph.

BELOW—Here we see a diver with good buoyancy control.

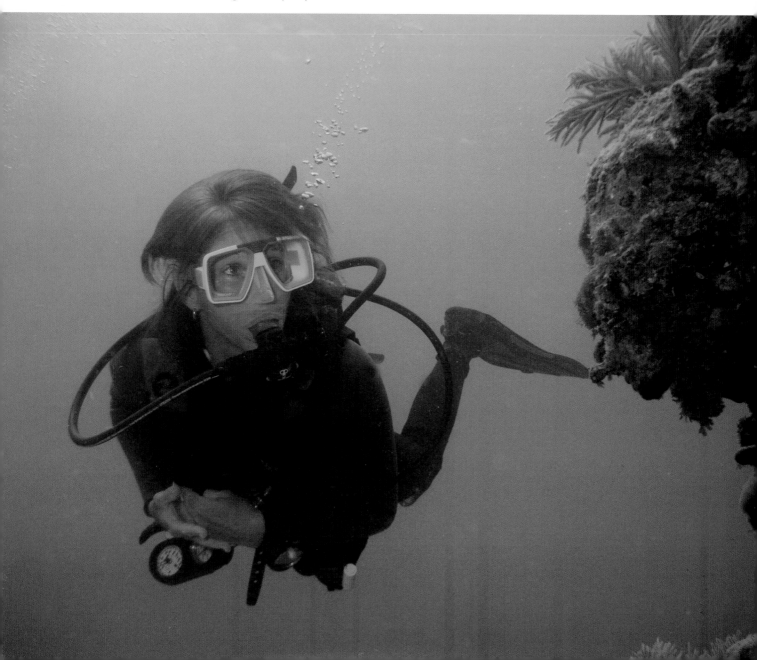

have inadvertently contacted the coral, feel your fins after a dive. If they feel slimy, you have.)

Achieving good buoyancy control takes some practice, but it's a key element in coral conservation. Being able to move between each state of buoyancy (positive, neutral, and negative) on demand allows you to hover in the desired position to take your photograph without contacting the coral. It will also enable you to move slowly enough through the water column that you don't scare off the subject you are trying to photograph or agitate the bottom content, reducing visibility and creating backscatter in the image.

## FINAL THOUGHTS

You don't need all of the latest scuba gear or photo equipment to be a good underwater photographer. What will make your images better is practice. The amount of photography gear you are toting can affect your buoyancy and diving, just as any additional piece of scuba gear does. It can also influence the amount of weight in your weight system. So, if you are going to practice your diving skills, like buoyancy control, by all means practice with your camera gear.

By the way, you don't have to travel to the premier dive destinations of the world, spending precious vacation time and great sums of money to practice your skills. For underwater photography purposes, spending quality time in any pool with your scuba gear and camera will work!

You want to picture yourself more akin to the divers shown in these images than those coral-crashers in the images featured at the top of the facing page.

# 2. THE VALUE OF UNDERWATER PHOTOGRAPHY

When I was just starting out in underwater photography, I wanted to take images I could share with my non-diving friends. There are, however, other benefits to underwater photography, and outlining them merits a chapter of its own—even if just a short chapter.

## IT'S FUN

The first value of underwater photography is that it is a lot of fun. It's easy to fall in love with underwater image cap-
ture—and for this reason, you may find that it can be very time-consuming.

## IT PRESERVES MEMORIES

A couple of years ago I was discussing the values of underwater photography during one of my photography courses. A student, bless him, agreed with all the values I had stated and then asked, "Yeah, but Larry, isn't saving our memories an important and good value, too?" I was taken aback

A community of copper sweepers often forms inside the shelter of caverns.

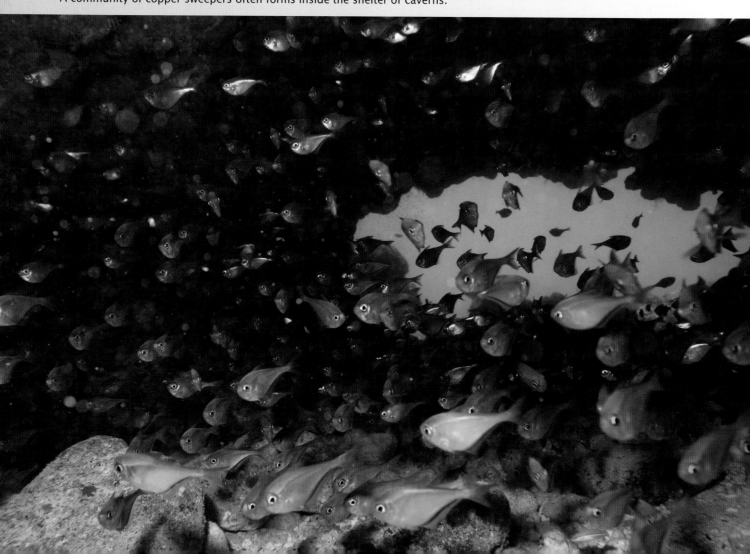

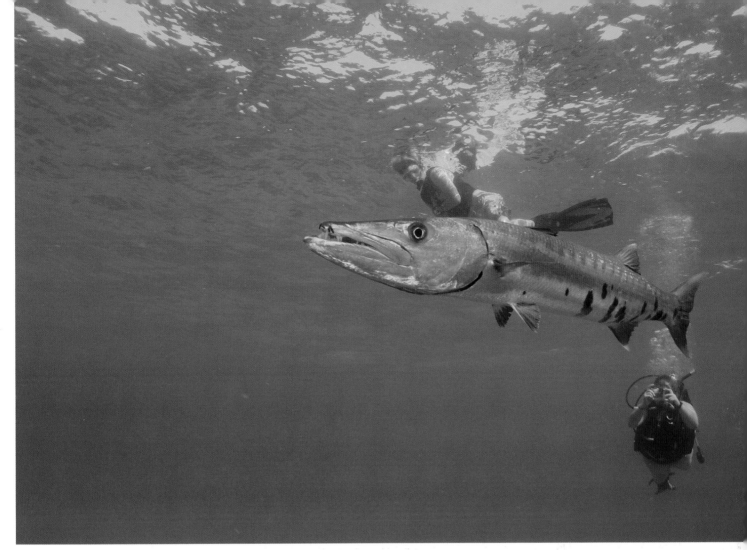
A large barracuda oftentimes captures everybody's attention.

because I had totally overlooked this value. I immediately agreed with him.

## IT'S A CREATIVE CHALLENGE

How could I possibly forget the preservation of memories as a valuable outcome of underwater photography? Well, because I get caught up in the challenge of it—something I also find valuable. I find myself wanting a better image of each subject or thinking about underwater scenes that I have yet to capture. Additionally, when I see great images by other photographers, I want to create images like them for my own repertoire. In this way, underwater photography opens the door to my own creativity and gives me an avenue of self-expression.

## IT MAKES DIVING MORE FUN

Underwater photography also gives us something to do while scuba diving. A years' old dive-industry market-re-

search study revealed that people often quit scuba diving because they had nothing to do when diving! When the novelty of diving wore off, many people moved on to new adventures. Underwater photography gives us a reason to continue scuba diving.

## IT CAN BE PROFITABLE

Underwater photography can be a lucrative venture. (If I did not have your undivided attention before, I'll bet I have it now!) Anyone who has a dwelling adorns it with some form of wall art. Wall art of any form is not free. Simply hanging one of your own images on an unadorned wall will at least save you some money—and if that image is nice enough, it may appeal to others, as well. A print of your image may also make a valuable gift.

Once you determined that your images have value to others, you can begin to market them. Launch a web site and set up an online gallery of your images. Do a show

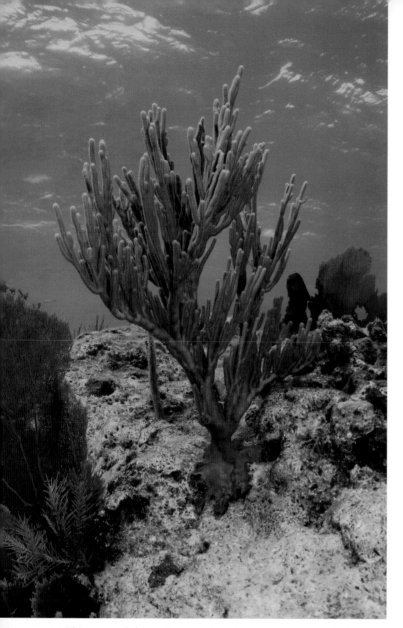

This sea rod decorates an otherwise barren portion of the reef.

their winning images published. The range of categories is wide; most encompass all subjects, and all types of cameras and lenses can be used. It is fun and rewarding to participate in contests, whether you win or not.

## IT'S SOCIAL

To me, another great benefit of underwater photography is that it is very social. I've made new friends just because I am an underwater photographer. I've witnessed others making new friends, too. When I am on a dive boat, I see people exchanging contact information after one diver takes a picture of another. It happens every day.

## IT'S EDUCATIONAL

Underwater photography is also educational. The education is not limited to underwater photography—I've learned a great deal about completely different topics. Since buying my first digital underwater camera, for example, I have learned more about my computer. I have also learned much more about the marine environment and its inhabitants than I otherwise would have.

Recognizing all of the good that comes from your endeavors will help you to further your skills. Recognizing the value of what you are doing will improve your attitude. Rather than viewing underwater photography as something that is difficult, you will see it as enriching. Armed with a good attitude, underwater photography becomes easier and much more fun.

and display them at a brick-and-mortar gallery. Display and sell them at a local art fair. You can also seek to get them into print. You may be able to provide images to stock agencies. Dive publications sometimes need illustrations for various articles, as well. Take a look at one of the many price guides available; these can help you to determine the worth of an image.

## IT'S COMPETITIVE

For people who have a competitive streak, there are many underwater photography contests. They are not difficult to participate in, and some do not even require entry fees. Most contest winners are awarded prizes such as scuba equipment, camera equipment, and trips. They also get

# 3. EQUIPMENT

If underwater photography is perceived as being difficult, selecting your camera, accessories, and components adds to that perception—indeed, the perception may actually *begin* with the process of selecting your equipment! This is especially true for those looking to purchase digital underwater photography gear. Your underwater camera system can cost as much as (or more than) your scuba equipment—and, unfortunately, holds its value just about as well.

As I was writing this book, I counted over three-hundred camera models, by various manufacturers, that could be housed and used underwater. Yet, while there are countless options, your equipment can actually be quite simple. (*Note:* Although there are still film cameras being used—Nikonos models, other amphibious cameras, and SLRs—film cameras are no longer either being made or actively marketed, so this chapter concentrates almost exclusively on digital equipment. This is not the case throughout the rest of the book, where the majority of the techniques apply to both film and digital photography.)

## BASIC COMPONENTS

There are three basic components to an underwater camera system, whether it is film or digital. First is the camera, which may be amphibious or placed in a housing that allows it to be used underwater. Second is the lens, which may be native and fixed to the camera body or separate. Third is an auxiliary light source—an on-board camera flash or an external strobe.

## A BACKWARD PLAN

In selecting a camera or camera system it is wise to "backward plan." I first heard this term while in the military. Essentially, backward planning means deciding beforehand where you want to end up, then planning backward from

there. For example, if I want to end up shooting small creatures or critters, like banded coral shrimp, arrow crab, Christmas tree worms, and the like, then I'd want to obtain a camera system and/or lens that is well-suited to meet that goal. In this case it would be a macro lens.

You might not know what you want to photograph. If not, then think about what it is you like to see when you

A snorkeler passing over the coral reef below adds an element to this scenic.

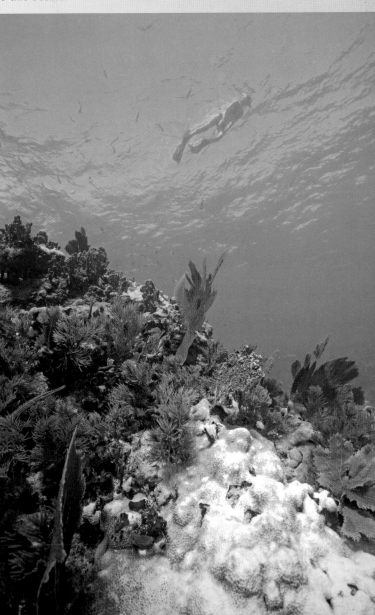

are diving. That may provide an answer as to what type of photography you'll end up favoring. Then, using the information below, you can begin to plan backward from there to select equipment that will meet your needs and give you great results with the subjects you prefer to photograph.

## CAMERAS

There are essentially three types of digital cameras used in underwater photography: point-and-shoots, what I call "full-featured" digital cameras, and digital single lens reflex (dSLR) cameras.

There is no one camera or system that can do it all. By this I mean there is no one camera system capable of taking photographs of any and all subjects that could present themselves to the photographer on any given dive. This is because of the range of the sizes of subjects we have the potential to photograph—from sunken ships to pigmy sea-horses. That said, there are camera systems that can do a great deal—and any one of the three types of cameras we use are quite capable if used within their limits. No one camera or lens is master of it all!

**Point-and-Shoot Cameras.** The first type of camera, the point-and-shoot, is the simplest in terms of ease of use. It is also the most compact camera—even in its housing and when complemented by an external strobe. It travels well with respect to both your actual trip and when handling it underwater. It is also the most affordable camera relative to the two other types of cameras.

*The Features.* When considering an underwater camera system, one wants to consider the four elements that comprise the making of an acceptable image (for more on these elements, look quickly ahead to chapter 4). Point-and-shoots have the first element pretty much covered: they all have the ability to autofocus.

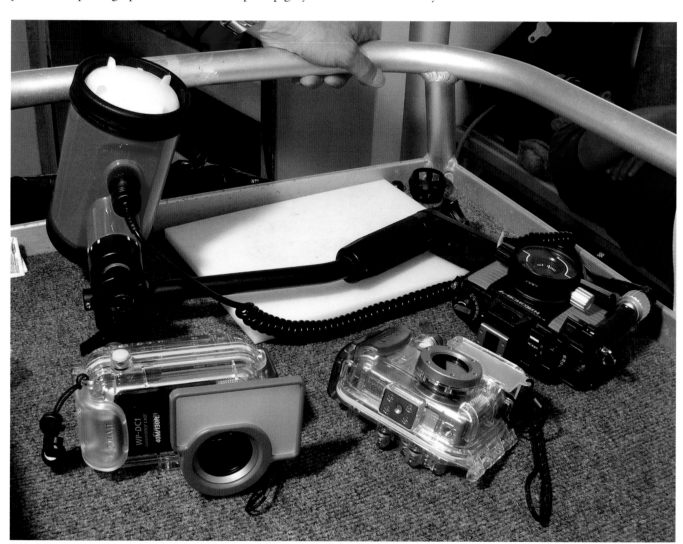

Two point-and-shoot cameras next to a Nikonos V film camera system.

When it comes to the second element, exposure, point-and-shoots offer the photographer little control. Although you can select from a number of scene modes—macro, sports, portrait, landscape, and sometimes even an underwater mode—most point-and-shoots do not offer full manual settings. Typically, point-and-shoot cameras will allow you to set only the ISO, the white balance, and exposure compensation. You may also have some control over the flash/strobe output.

The third and fourth elements of an acceptable image, composition and subject, are governed more by the photographer's technique and the lens—not so much the camera. So point-and-shoots can cover these bases.

*The Drawbacks.* Point-and-shoot cameras are generally designed with only one lens in mind—and the lens is part of the camera. Typically, this lens fits into the "standard" lens category, although, it may offer a variable zoom focal length. The zoom feature often has two components: optical zoom (usually at 3x or 4x) and digital zoom (sometimes out to 12x). When using this camera, either zoom with your fins (which is to say, get closer to your subject) or stick to the optical zoom range. The digital zoom crops out image data and limits the size of the printed enlargements you'll be able to produce from the image file. This means you are relegated to shooting only the subjects that are best photographed with the lens angle-of-view that is native to the camera.

Another trade-off with point-and-shoots is lag time (a short delay between when you push the shutter button and when the image is actually captured) and the time between shots (how long it takes for the camera to clear the data from the previous shot and make itself ready for the next capture). Point-and-shoots can also be slower to acquire focus than other types of digital cameras.

Additionally, you do not have control over the camera's shutter speed or lens aperture when using a point-and-shoot camera. Therefore, you must be sure to take control of the settings you *can* adjust—don't just let the camera decide. Pick the ISO setting you want and adjust the exposure compensation as needed. This allows you to "trick" the camera into making an exposure setting under or over what the camera "thinks" is correct. I recommend that you set your exposure compensation to underexpose by a fraction of a stop (–⅓, –½ , –⁷⁄₁₀ or –.3, –.5 or –.7). This will help compensate for the tendency of digital cameras to

*TECHIE TALK*

## ISO

The International Organization for Standardization (ISO) is an organization that sets standards for manufacturers. Once a product meets that standard, the maker can use the label "ISO" on their products. With respect to photography, an ISO rating is used to indicate how quickly a light-sensitive element (like film or an image sensor) reacts to light. This is a key element in predicting correct exposure settings. (*Note:* It is my view that ISO standards were more accurately adhered to when labeling film than with digital ISO settings. In the digital world, I think the given ISO rating seems slower—less sensitive to light—than the ISO rating indicates. I have not done a study of this—but that's part of what makes "techie talking" fun!)

overexpose bright areas in the frame. This is especially important with point-and-shoots, since their sensors have less dynamic range (see page 47).

*Overall Performance.* As long as you know those limits, you can shoot well using a point-and-shoot camera. There are many underwater subjects that are well-suited to being photographed with the lenses that are native to the point-and-shoot camera. These include reef fish (down to the size of your hand), turtles, eels, lobster, head-and-shoulder portrait shots of fellow divers, skittish sharks and rays, individual stands of coral (such as elkhorn and staghorn corals), and the variety of sponges and gorgonian corals. And, as luck would have it, all of these subjects are a heck of a lot of fun to photograph!

## As long as you know those limits, you can shoot well using a point-and-shoot camera.

In addition, most point-and-shoots offer a macro mode that enables you to photograph subjects that are too small for the native standard lens's angle of view. I have seen some incredible photographs of Pederson shrimp and banded coral shrimp taken using point-and-shoot cameras set to their macro mode.

**Full-Featured Cameras.** The second type of digital camera we use is the full-featured camera. These cameras

offer all of the same features as the point-and-shoots but add some important features into the mix.

*The Features.* One of the most important functions you gain when choosing a full-function digital over a point-

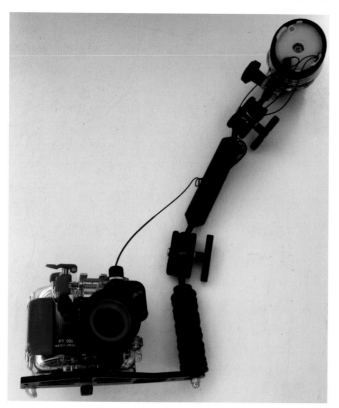

A full-featured digital camera with camera tray, handle, clamp, strobe arm, strobe head adapter, fiber-optic synchronization cable, strobe, and diffuser.

and-shoot model is full manual control of the shutter speed and aperture.

Many full-featured digital cameras also, either by design or ingenuity, offer the photographer a variety of means for the camera to communicate with the external strobe. This gives the photographer a bit more flexibility or control over the strobe choices and its output.

As these cameras were really made for top-side photography, some offer add-on lenses. The manufacturers of underwater photographic equipment offer a variety of auxiliary wet-mount lenses (lenses that can be changed underwater during the dive). Typically with a full-featured underwater camera system, the photographer can add a macro lens or a wide-angle lens to the camera.

The full-featured cameras can be quicker to achieve focus than point-and-shoots, making it possible to shoot more quickly. Unlike dSLRs (see below), however, they typically do not have a buffer, so you are still going to encounter some lag time (see page 36).

*The Drawbacks.* The trade off with the full-featured digital camera systems is that they are more expensive. Also, they tend to be bulkier in the water and take up more space when packing for a dive trip.

*Overall Performance.* If there is one camera system that comes close to doing it all, in my opinion it would be the full-featured digital camera. I do find that even "regular guy" photographers, myself included, tend to outgrow the limits of the point-and-shoot cameras. They eventually want more control over their exposures and lens choices beyond what is native to their point-and-shoot system. The full-featured cameras fill that role well.

**Digital SLRs.** The third type of digital camera we use is the digital single lens reflex (or dSLR).

*The Features.* There are, in my opinion, several advantages to the dSLR cameras. First, they achieve focus more quickly, allowing you to shoot rapidly. You'll also have less wait time between frames because their design incorporates a buffer. Because the data from the sensor is immediately dumped to this buffer (and from there, written to the memory card) the sensor is almost immediately ready for the next shot. Additionally, the image sensors incorporated into dSLRs are of a higher quality per megapixel. Personally, I also find that I can "see" better what I am shooting using a dSLR's viewfinder rather than the LCD screen on a point-and-shoot or full-featured camera. This means I

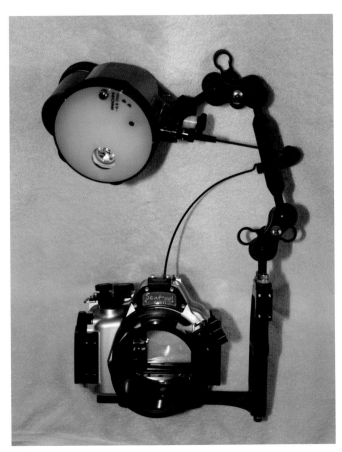

A digital single lens reflex (dSLR) with housing, port, camera tray, handle, clamp, strobe arm, strobe head adapter and strobe, diffuser, and a fiber optic array.

can usually make a more accurate composition using a dSLR. You can also use a wide variety of interchangeable lenses on these cameras. Digital SLRs offer all of the manual exposure controls you'll need—but professional models forego the incorporation of any "scene modes" or a fully automatic setting (also called the "Larry-proof mode").

*The Drawbacks.* Digital SLRs (dSLRs) are much bulkier—in and out of the water—than the other types of cameras. As such, they do not travel quite as easily.

Built to a higher quality with superior sensors, these cameras are also far more costly than the other two types. The cost of the dSLR camera body itself can exceed the total cost of either a complete point-and-shoot or full-featured camera system—and the lenses are no cheaper. You will also have to contend with the additional costs of a much more complex housing and the ports needed for each lens type you want to use.

*Overall Performance.* There's a reason that professional photographers choose to shoot with dSLRs: they offer the most possible creative control. If you're willing to make

the investment and spend some time mastering the tools, no other type of camera offers more options or flexibility.

## HOUSINGS

When we contemplate submerging a camera, we must have some means of ensuring that we keep it dry. There are two ways we can meet this requirement. The first, and these days the least often used, is an amphibious camera. That is a camera that was built to both withstand the pressures we divers will subject it to and to be waterproof. The Nikonos cameras are of the amphibious type.

The second method used to submerge our cameras is to install it in a pressure-proof and waterproof container called a "housing." Housings capable of such service are made of plastics, polycarbonate, and metals, such as aluminum. Polycarbonate housings for point and shoot digital cameras can be purchased for under $200, while some metal housings for dSLRs can cost well over $5000.

There are housings, made by camera and third-party manufacturers, for all types of digital cameras—including point and shoots, full-featured digital cameras- and dSLRs. A number of years ago, while on-line I wandered across a website that listed cameras and housings and the number totaled over three hundred! However, there are many more than three hundred camera models on the market. Therefore, when you are deciding which camera to purchase for use in underwater photography (assuming you are not purchasing an amphibious model), you must be sure that someone makes a housing for it.

When selecting a housing, make sure it has an operational depth that meets or exceeds the depths you plan to

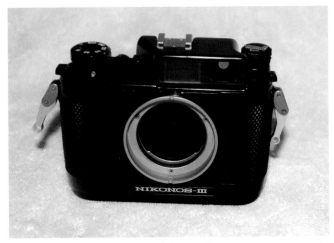

The Nikonos III, a 35mm amphibious film camera, was a workhorse in its day.

dive to. Also keep in mind that housings offer either limited or full access to the camera's controls. If you are contemplating buying a model with limited controls, make sure you can live without whatever controls the housing's design does not offer access to.

The trend in housings is to make them as small as possible while affording as much access to the camera's controls as possible. This is because smaller underwater camera systems are easier to dive with. Of course, one can also reach a point of no return with respect to size; too small of a housing can make operating the controls difficult from an ergonomic standpoint. So, size is also a consideration.

Housings made for use with point-and-shoots and full-featured digital cameras have lens ports incorporated into their construction. Housings made for use with a dSLR re-

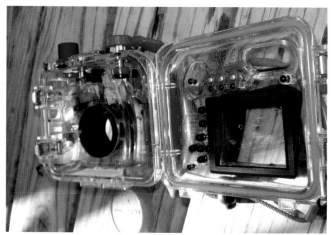

A housing machined from a single block of aluminum.

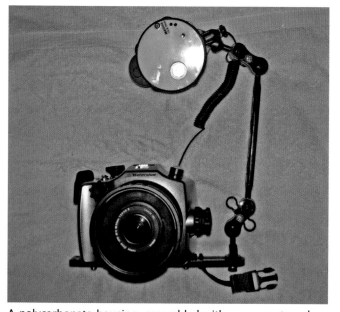

A polycarbonate housing, assembled with a camera tray, lens port, and external strobe.

Underwater camera systems vary with respect to buoyancy; they can be negatively buoyant, positively buoyant or neutrally buoyant. This has to do with the size and weight of the camera, lens, housing, camera tray, arms, clamps, and external strobe. By adding weights or floats, the buoyancy of your underwater camera system can also be adjusted to suit your preference.

There is no right or wrong choice—in fact, there is not much consensus or preference among underwater photographers. I personally prefer my camera system to be slightly negatively buoyant, mainly because this means it will stay put if I want to set it down during my dive.

quire external lens ports that are made for and used with specific lenses for the dSLR camera body. These ports, which surround the lens, mount to and are sealed with the camera housing. For example, if you wanted to use a macro lens on your dSLR, your would need to buy both the housing for the camera and a port for the macro lens. If you also shoot with a wide-angle lens, you'd need to purchase another port to accommodate that lens.

## LENSES AND FOCAL LENGTH FACTORS

Digital cameras capture photographs using either a CCD (charged coupling device) or a CMOS (complementary metal-oxide semiconductor) image sensor. However, unless you have what is called a "full-frame" digital camera, the dimensions of the image sensor will be smaller than a 35mm film frame. This has implications for lens selection.

When using a camera with a less-than-full-frame sensor, lenses have what is referred to as a "multiplier" or a "multiplication factor." As of this writing, Canon's sensor dimensions result in a multiplier of 1.6x; Nikon's sensor dimensions result in a multiplier of 1.5x; Olympus's is 2x. These multipliers are used to determine the equivalent angle of view (focal length) of a given lens when it is used on a particular digital camera rather than on a 35mm film camera.

This is important when selecting lenses for a dSLR (and, for that matter, when buying a point-and-shoot or full-functioned digital camera with a fixed lens). If I am contemplating buying a lens for my dSLR and want one that gives the equivalent angle of view of a 20mm lens (a mod-

erately wide angle lens) on a 35mm film camera, I need to consider the multiplier in making my choice. If I simply buy a 20mm lens for a Canon dSLR, I will end up with a lens that actually has an angle of view of a 32mm lens on a 35mm film camera (20mm x 1.6 = 32mm). This is still wide—but not as wide as the 20mm angle of view I wanted. To get that true 20mm angle of view, I would need to purchase a lens with a focal length of around 12mm for my Canon dSLR (12mm x 1.6 = 19.2mm). Now I've got the lens with the angle of view that I originally wanted!

Fortunately, the makers of the lenses often list the 35mm film camera equivalent for the lens's focal length. That helps! Another helpful thing they sometimes do is actually label the lens as a wide-angle or macro lens.

Your challenge, then, is either to pick the right focal length for the subject—or, if you cannot change or zoom the lens, to choose subjects that are appropriately sized for the angle of view of the lens you have. If you mismatch your lens and subject you'll end up with one of the following problems. You may have an incomplete image because your lens did not have a wide enough angle of view to get the whole subject in the frame. Or, the subject may not fill a pleasing percentage of the frame (it will be small and hard to see) because your lens has too wide an angle of view for the subject size. You may even end up with a monochromatic image because your lens's angle of view was not wide enough to capture the whole subject without moving too far back (for more on the loss of color from shooting through the water column, see page 45).

## EXTERNAL STROBES

No underwater camera system is complete without an external strobe—and my chapter on equipment cannot be complete without a discussion of them!

The external strobe is an important piece of equipment and its cost can rival the price of the camera—and exceed the price of some lenses we regular guys are likely to buy.

## FISHEYE LENSES

Fisheye lenses have an extremely wide angle of view—outward to 180 degrees—but also produce significant distortion. Fisheye lenses bend any straight lines in a photograph, especially those lines that fall away from the center of the photograph. Fisheye lenses are considered specialty lenses, but they are often used in underwater photography as wide angle lenses. (*Note:* Other than fisheyes, most other lenses are considered rectilinear, meaning that they render straight lines as straight lines.)

*This topside photograph shows how a fisheye lens affects straight lines. Note the curvatures of the horizon and the back of the upper deck on the boat.*

If, like me, you are always on a budget, you may start out with just the camera and began your adventure in underwater photography using either ambient light or the on-camera flash. The next purchase of underwater photography equipment you will likely make, though, is an external strobe. The following are the features that I look for when deciding which strobe to buy.

**Angle of Coverage.** When most strobes are discharged, they produce a conical beam of light. However, depending on the design, the width of this beam of light will vary. What you want is for the strobe's angle of coverage to be at least as wide as the angle of view of the lens. For example, if I am shooting with a lens with an angle of view that is 80 degrees (say, a 20mm lens), then my strobe should also have a coverage angle of at least 80 degrees. If the strobe does not cover the lens's angle of view, the result

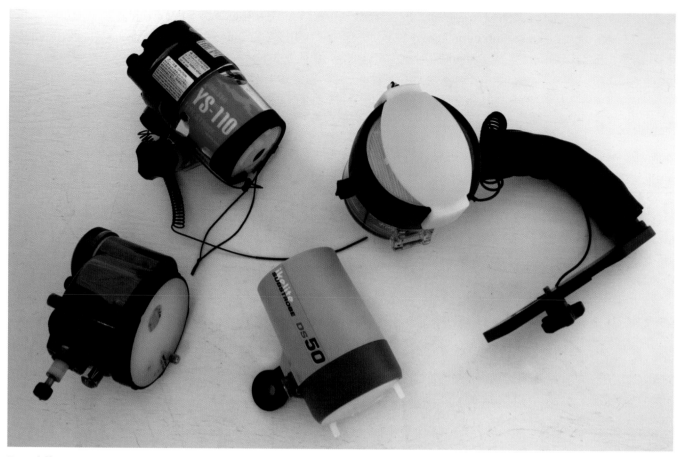

Four different strobes from four different manufacturers.

will be light falloff (darker areas) in the corners and along the edges of your photograph. (The same thing can happen if you do not properly aim your strobe.)

I prefer to shoot with wide-angle lenses, therefore my strobes have angles of coverage that accommodate the widest of these lenses—approximately 100 degrees. I recommend a strobe with close to 100 degrees of coverage. That way, if you ever end up shooting with a wide-angle lens you won't need to purchase another strobe to cover its angle of view. This strobe will more than cover the angles of view of the other lenses with longer focal lengths.

**Power and Color Temperature.** The power of the strobe and its color temperature are two other considerations that are part of my decision making. A strobe's power is sometimes measured in watts or by a guide number. I prefer a 100 watt or greater power in my strobe and or a guide number (GN) of 30 or greater. A preferred temperature is a bit easier. Most strobes are made with a temperature (measured in degrees Kelvin) ranging between about 4800 and 5500 degrees Kelvin. A strobe with a temperature within this range is workable for me.

**Recycle Time.** A big consideration is the strobe's recycle time. This is the time required for the strobe's power source (battery pack or batteries) to recharge the capacitor and be ready for the next shot. When purchasing my camera I've already given consideration to how much time it takes to be ready to take another shot, and it can be frustrating when the camera and I and the subject are all ready for the next shot—but we're all waiting for the strobe to recycle! I can be slow in re-composing for the next shot, but generally I have my next shot of the subject in my mind's eye within a second or two. I want my flash to be ready so I don't miss a great opportunity.

**Power Source.** You may also want to consider how many full-power "dumps" (pictures taken at full strobe power) you will get from the strobe's power source. I am a relatively modest shooter; if I get really busy with a subject or with my photography, I will still only shoot around a hundred frames during the course of two dives (a half day). Power management is a concern, though, in the digital paradigm—both with respect to the camera and the strobe. With the ever-increasing sizes of memory cards we

can use, we can certainly take more photographs than we would have in the film era, but this number may be limited due to either the depletion of the camera's or the strobe's power source. So part of your purchasing decision for either device should be how much of a power hog the device will be!

**Power Settings.** Another consideration I make when choosing a strobe is how flexible it is with respect to power settings. Of course, all strobes have an on/off setting—and "on" typically means the strobe will be firing at its full power. But does it offer any "in between" choices? Does it have half power, quarter power, or other incremental settings? A quick and easy way to adjust exposure is to control the output of the strobe's power. Most strobes made now do have this feature.

**TTL Metering.** As of this writing offer, most strobes offer TTL (through-the-lens) metering, which allows the strobe to communicate directly with your camera. If you believe you will favor TTL, you want to make sure that the strobe's TTL will work with the camera you have or are buying. Theoretically, this technology makes obtaining correct exposure an idiot-proof process, so that all elements of the image—the subject, foreground, background, and water column—will always be correctly exposed. Some shooters swear by TTL as a means to govern strobe output; others swear *at* it. For more on TTL metering and exposure, see pages 44–45.

**Diffusion.** I like to use a diffuser, a translucent plastic disc that fits over the face of my strobe. This diffuses the light, widening its angle of coverage by approximately 10

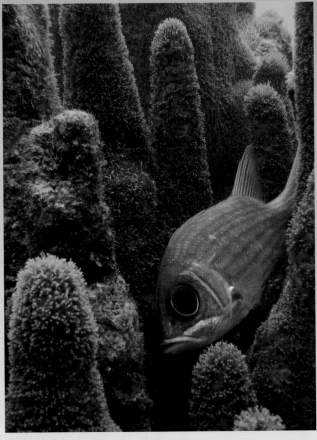

*Without fill flash.*

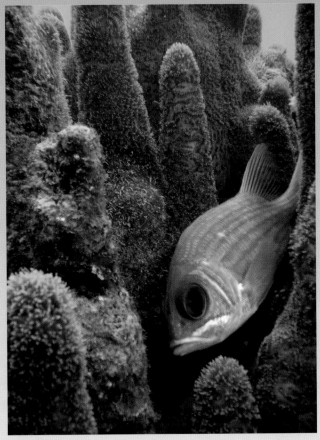

*With fill flash.*

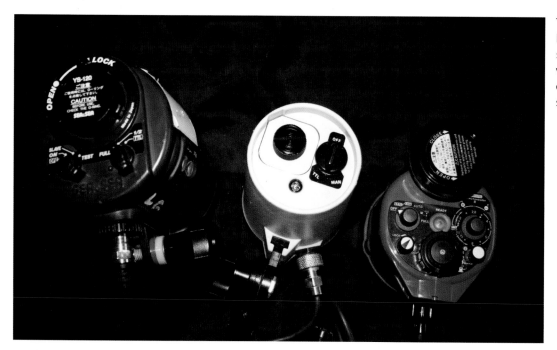

This photo shows the backsides of three strobes, revealing a variety of settings—on/off, manual, power settings, and TTL.

Diffusers are detachable and often secured to the strobe head using a cord or a fixing screw.

degrees and reduces the output by about one stop. Digital cameras have a tendency to wash out or overexpose the highlights and a diffuser helps guard against this tendency.

**Modeling Light.** Some strobes have a built-in modeling light. This is a continuous light source that is used for positioning the light and focusing (which is helpful when shooting into dark areas with little contrast). A modeling light is particularly useful if you will be engaged in underwater photography during night dives.

**One Flash or Two?** In my opinion, there is no one answer to that question. It depends on your wants or needs. The two schools of thought on this question can discuss the merits of both amongst themselves, but I believe in the "one sun" concept. There is only one sun, so I use only one strobe. However, if your one strobe does not have a beam angle broad enough to cover the angle of view of your lens, then you would have a need for two strobes.

**Mounting to the Camera (Or Not).** In most cases, strobes are united physically to the camera—usually via a camera tray that attaches to the underside of the camera or its housing. To that camera tray, a handle (or fixture that will hold a clamp to secure the strobe arm) is mounted. From there, arms and clamps of varying numbers and lengths lead up to a strobe head adapter that is bolted to the strobe head, completing the marriage. My view is to start out simple—a tray, handle or arm (skipping the handle), clamp, arm, clamp, adapter, and strobe head. If you get carried away, you end up diving with the underwater version of an Erector set!

The clamps are adjustable, allowing you to increase or decrease the tension on them and adjust the position of the strobe head as needed. I want my arms/clamps array to enable me to position my strobe directly on top of my camera, overlooking its lens and also to be able to change the strobe-to-subject distance by approximately one foot from where I would normally have my strobe positioned. In most cases, the strobe is mounted to the left side of the camera, when holding the camera.

If you prefer to forego the tray, handle, clamps, and arms, you can also choose to handhold your strobe. This is an effective technique, but it requires good buoyancy

## TECHIE TALK
# SPECULAR HIGHLIGHTS

This is a term used to describe light that has reflected brightly from a shiny surface, such as a chrome-plated part of a regulator or tank valve. Specular highlights differ from clipped highlights (highlights with no detail) in at least one way: while they are not desirable, they can be acceptable. A specular highlight is a reflection from something; a clipped highlight is an overexposed area in an already bright portion of the photograph.

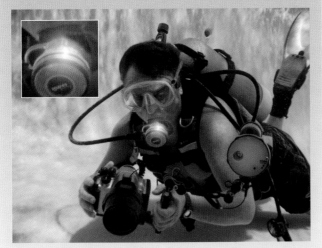

*Example of a specular highlight.*

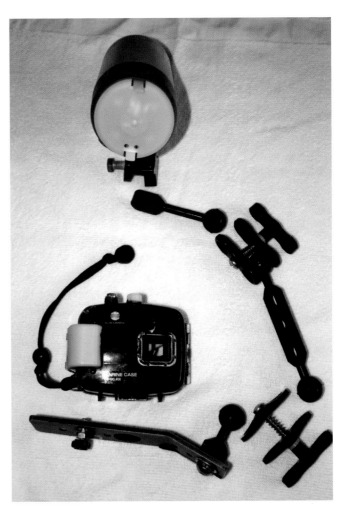

This photo shows a digital camera system. You see the housing, along with a camera tray, adapter, clamp, strobe arm, clamp, strobe head adapter, and strobe head with diffuser in place.

control; when you opt to handhold your strobe, both of your hands will be full. Handholding your strobe enables you to adjust for exposure simply by changing the distance of the strobe to the subject. One foot of distance toward or away from the subject equates to one stop of exposure (plus or minus, respectively). One trick to remember when handholding the strobe is to account for the refraction of the water; things will appear closer than they are, so you'll need to adjust your strobe accordingly. If you don't, you will find your strobe front lighting your scene.

A split-the-difference method between mounting the strobe and handholding it is to buy a handle that has a quick-disconnect (QD) feature. The QD feature allows you to remove your handle, and hence the strobe arms and head, from your camera tray in order to temporarily handhold and aim your strobe.

**Communication with the Camera.** The second connection between the camera and strobe is how they communicate with each other—after all, communication is the secret to any good relationship. There are three ways this

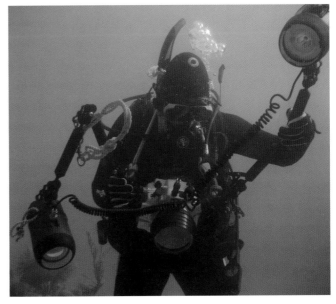

Some assemblies are on the scale of an Erector set—not that there is anything wrong with that! This image also shows a system with two strobes.

## MASKING THE FLASH

When the camera's on-board flash is used to make the communication marriage, it is important to mask its light so that it will not contribute to backscatter. A couple of field-proven methods of doing this are using black electrician's tape, black paint, or black permanent marker in the appropriate areas.

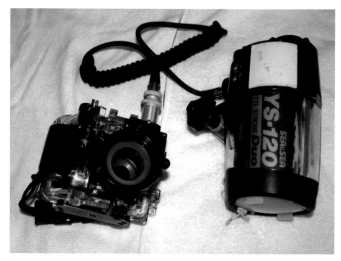

The camera and strobe are set up to communicate via a synch cord.

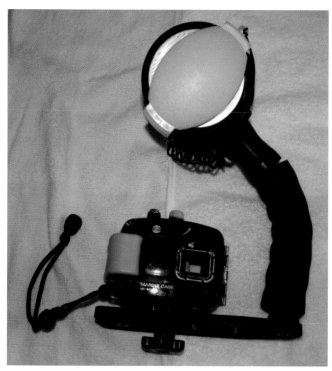

The strobe is slaved to the camera.

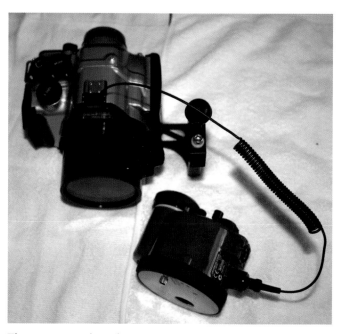

The camera and strobe are set up to communicate via a fiber optic cable.

is accomplished: slaves, synch cords, and fiber optic arrays.

*Slaves.* In a slave system, the strobe is equipped with a light-sensitive sensor. When the camera's built-in flash discharges its light it is detected by the sensor on the strobe, triggering it to fire in synchronization with the camera's flash and shutter. This works, but in my view it's not ideal. I've seen other light sources (such as the sun or another photographer's strobe) cause the strobe to fire. Alternatively, if the strobe's sensor does not pick up the camera's flash, the strobe will not fire at all. Also, even if the built-in flash is diffused, it can still produce enough light to make backscatter visible. If you are considering using TTL, check the specifications of the strobe/camera to ensure the two will communicate via slave.

*Synch Cords.* Another method of connecting the strobe to camera, predating the slave method, is the use of a syn-chronization cord. This coiled cord connects the camera to the strobe using threaded fittings. These connections on the camera and strobe are made watertight by O-rings, which demand diligent care and maintenance. Thus, while synch cords offer a reliable mechanism for camera-to-strobe communication, they also present two points for potential floods. Additionally, the cords themselves are somewhat fragile and don't take kindly to being over-stretched or bent at sharp angles. For the most part, though, this method is very reliable and robust. Also, because the camera's built-in flash is not part of the picture, the risk of backscatter is less. TTL is available, in most in-

stances, with the appropriate synch cord; check with your equipment provider to ensure you get the right one.

*Fiber Optic Arrays.* The latest method of establishing communication between the camera and strobe is the fiber optic array. This method is sort of a cross between the other two. Like the slave method, it uses a sensor on the strobe head and the camera's on-board flash. Like the synch cord method, it also uses a cord—a fiber optic cable. One end of the cable is fixed to or near the strobe's sensor; the other is fixed near the camera's flash. The fittings on each end do not penetrate either the strobe or the camera, so there is no concern for flooding and no real maintenance involved. The fitting on the strobe shields the sensor so external light does not cause the strobe to fire when it shouldn't—and the camera-end fitting often masks the camera flash, preventing or reducing backscatter. If TTL is being considered, check with your equipment provider to ensure that a fiber optic array will work with your system.

## USE YOUR EQUIPMENT TO ITS FULL POTENTIAL

If you are purchasing a camera system, try to buy one that you can grow into and has some versatility. Buy quality; it will cost you more up front, but you will likely use the system for much longer and get more utility from it.

Even if what you end up with is not taking the kind of pictures you had hoped to take, do not immediately sell it and buy again. It is more likely that you, not the camera, are the problem. I have a student who owns a very expensive metal-housed Nikon dSLR with the full array of lenses and strobes (yes, strobes—as in *two*). The camera has ample resolution to make nice enlargements, which adorn his walls at home and work. Still, when Nikon came out with a new and higher-megapixel camera, my student e-mailed me and said he was thinking of selling his current system and buying the new model and its housing. My advice to him was to save the money. Buying a new camera wouldn't make his photography any better than before—and there was/is nothing wrong with his photography, then or now. He is still shooting this first camera and his photographic technique is improving; consequently, so is his imagery. A new camera system would not have made any difference to his photography. (His wife thinks I am very smart, by the way!)

Any one of the three types of cameras is probably more capable than most of us are. Whichever camera you find in

*Detritus is evident at the top of this photograph.*

your hands, be patient with it and yourself as you learn to use it to its fullest potential. Once you've done that and reached a point where you know that the system in your hands can't give you the results you want, only then is it time to consider a different system or an upgrade.

A nice thing about underwater photography and its equipment is that it is scalable. If you don't want to invest many dollars in your system right up front, you don't have to. You can build your underwater camera system slowly, scaling it up as your skills grow and your budget permits.

At the store!

# 4. THE FOUR ELEMENTS OF AN ACCEPTABLE IMAGE

There are four elements or factors that photographers, or viewers of photographs, use to determine whether an image is "acceptable." These are: focus, exposure, composition, and subject. These elements are not equally weighted. For example, the subject of the photograph may be so compelling or rare that how the photographer composed it is of less importance. (On the other hand, if you were to take a photograph of me, it had better be nicely composed, well focused, and properly exposed!) These elements all combine and interrelate in the creation of an "acceptable image." An underwater photographer is often described as a good shooter when they consistently include all four elements in their images (or at least that's part of the definition).

This chapter delves into these four elements: focus, exposure, composition, and subject. It defines them and gives some background on each one. It reveals some problems you may encounter in dealing with each and suggests some solutions. When you've finished reading this chapter, you should have a working understanding of each of these elements.

> ## Another issue when working underwater is that something is always moving . . .

In the first paragraph of this chapter, I put the word "acceptable" in quotation marks. That is because what is acceptable to one viewer may or may not be acceptable to another. To me, an acceptable image is one that I and viewers of my image find pleasing. I gauge the success of the image using the four qualities mentioned above when making that determination. Now, let's take a look at each of these four aspects.

## FOCUS

The subject of an image is said to be in focus when it can be viewed clearly and a good amount of the subject's detail can be seen. If the subject is not focused, it is frustrating to view. Frustration is not an emotion a photographer wants to elicit.

Focusing underwater can be tricky. First, water refracts light, making objects appear closer than they really are. Focusing a lens is all about distance; if you do not correctly gauge the distance, your result will be an image that is out of focus.

Another issue when working underwater is that something is always moving—the photographer, the subject, or the water (the surge and/or current), or all three at the same time! These dynamics result in an ever-changing distance between the photographer and subject—and, remember: focus is all about distance. It helps to be a skilled diver so you can put yourself at the distance you want and maintain that distance for the heartbeat it takes to work the shutter release.

**Depth of Field.** Depth of field, the area between the nearest and farthest points from the camera that is considered acceptably sharp, also plays a role in focus. For every lens, each aperture setting (f-stop) renders a given depth of field. The higher the aperture number (the smaller the aperture opening) is, the greater the depth of field will be. Choosing the aperture that produces a depth of field that will include the subject we are photographing is critical to producing an acceptably sharp image.

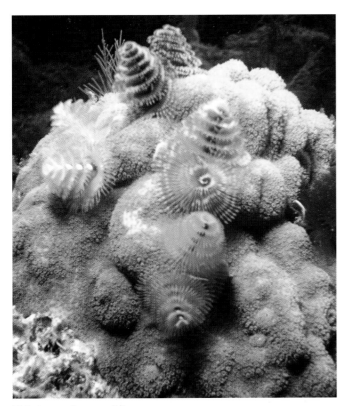

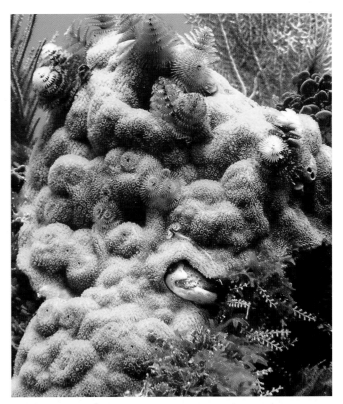

This image is out of focus.

This image is in focus.

Using a 55mm lens, this photograph was taken using a comparatively large aperture of f/5.6.

Using the same 55mm lens, this photograph was taken using a comparatively small aperture of f/16. When compared to the previous image, notice how much more of the foreground and background is in focus.

Different lens types produce a different amount of depth of field at a given aperture. Wide-angle lenses, for example, have a greater inherent depth of field than standard lenses have. For example, if a 20mm (wide angle) lens is focused at 2½ feet and its aperture is set to f/8, it will have a depth of field that extends from just under 2 feet to around 7 feet—a 5-foot band of sharp focus. Whatever is 2½ feet from the lens will be in sharpest focus. However, if I use a standard lens and use an aperture of f/8, the depth of field will be smaller, producing only about a 2-foot band of sharp focus. Incidentally, in both examples, it's important to note that the depth of field will be unevenly divided around the focused distance of 2½ feet. The area of the image that will be in relatively good focus is smaller in front of the focused distance and greater behind the focused distance.

In my opinion, one reason why wide-angle photography is popular is because of the depth of field advantage the

lens affords. Equipped with a wide-angle lens, even if I am a terrible guesser of distance—or my subject distance changes dramatically—chances are good that my image will be in focus. When shooting in a surge that moves you and your subject back and forth a foot or more, the greater depth of field afforded by a wide-angle lens gives you a significant advantage over the photographer working with a standard lens. (*Note:* Similarly, I think that macrophotography [close-up shots of very small subjects] became popular because focusing is simple. In film cameras, macrophotography was accomplished using a system consisting of an extension tube that mounted between the camera and lens. Attached to the underside of the camera or lens was a thin metal rod, and at the end of that rod, a framer. The length of the arm determined the correct distance for focus; if your subject was properly framed, the image would be in focus.)

**Fixed, Manual, and/or Automatic Focus.** So, how is focus achieved? Well, it depends on the camera one is using. The older, simpler to use, and less expensive cameras used in underwater photography have a lens with a preset (fixed) focus; for example, the focus may be set at 3 feet or 4 feet. Unfortunately, this is the only lens-to-subject distance at which you will get a focused image. This distance

Here a turtle poses for its portrait.

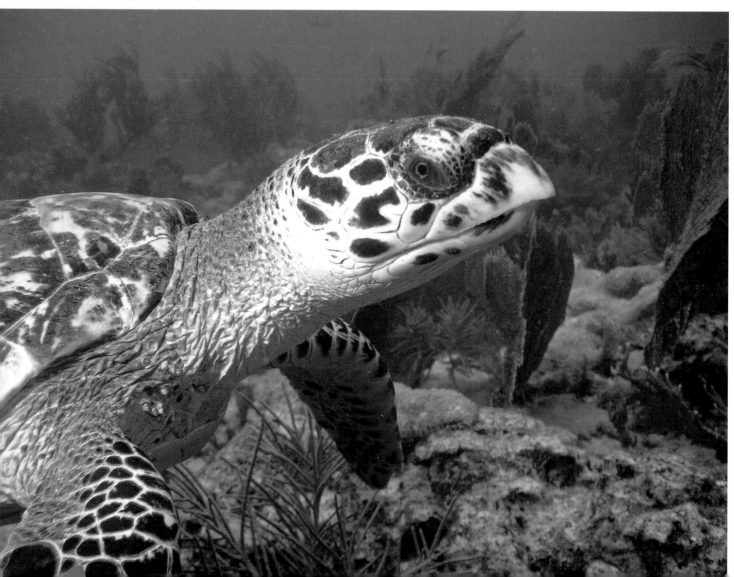

is fine if your subject is large enough to fill a pleasing percentage of the frame (more on this later in the section on composition), but it's not so great if the subject is small.

Another category of cameras features lenses that can be manually adjusted to focus to the apparent distance the photographer sees. This, of course, means that you must make a good guess about the lens-to-subject distance. Fiddling with the focus while you or your subject are moving and the distance is changing can cause you to miss the decisive moment. One way you can attempt to overcome this challenge is to shoot more than one frame of the subject or scene. Taking that second or third photograph increases your odds of going home with at least one image that is in focus. We can also preset our cameras and try to grab the shot when we are presented with that decisive moment.

Fortunately, most "regular guy" underwater photographers today use digital cameras, and all of these have automatic focus. Autofocus gives us a huge advantage, but it is not always foolproof. Most autofocus systems evaluate the contrast between dark and light areas in the scene to achieve focus. The more contrast you have in the scene, the more quickly the camera will achieve focus; the less contrast, the longer it will take the camera to achieve focus (and in some very low-light or low-contrast settings, it may not be able to focus automatically at all).

Today's digital cameras offer an array of focus settings including center (of frame), off center, above center, multiple point, closest object, continuous focus, focus lock, etc. Study your manual to learn about these options. Manufacturers do not always do the best job in explaining the terms used in their manuals, so if you do not understand a term, go online and look for a definition. You will likely find it explained in an understandable way in one or more of the search results.

Also, keep in mind that different companies often use different terms to refer to the same feature. For instance, Canon's focus-lock feature performs just like Sea Life's shark mode—it enables you to preset (lock) the focus on a distance at which you expect to photograph your subject. Once this distance is set, you can compose and take your picture without having to wait for your lens to achieve focus. This feature can be helpful when shooting macro images or using a lens with a long focal length. It's a technique that is often employed when trying to photograph a subject that is ducking in and out of cover. It also works when low contrast in the scene makes the autofocus system struggle.

Some camera makers offer an intuitive autofocus feature—Canon calls it AI Servo, while Nikon calls it Continuous. This feature allows the camera to sense a moving subject, predict its speed, and lock focus at whatever distance your subject is at when you fully depress the shutter. Using this feature can be helpful when photographing quickly moving subjects.

## TECHIE TALK
# CHROMATIC ABERRATION

Also called color fringing, chromatic aberration is caused when a lens does not correctly focusing the different wavelengths of light onto the same plane or magnifies them differently. When it occurs, it is visible as a color (sometimes blue) at the edges of areas in the image with high contrast. This is a lens issue, not a photographer issue.

Compare these two images. The left image appears as it should. The right image shows chromatic aberration (in this case, simulated)—particularly at the rock/water edge.

I keep things simple most of the time. When I am using autofocus, I use the center-of-the-frame focal point. I press and hold the shutter button halfway down, allow the lens to achieve focus on the subject, then compose the shot as I wish—because, with the focus locked, I can move the camera to the side to place the subject off center if I wish. Once I've composed the shot, I fully depress the shutter to take the photograph. Concurrently, I can also use aperture size to determine how much of the foreground and background I want in focus. Simple, right? (*Note:* This technique—especially depressing the shutter button only halfway when your camera is in its underwater housing—requires some practice. Fortunately, this can be done on land.)

Many newer cameras also offer a manual focus option. I often use manual focus when shooting with a wide-angle lens. This works because a wide-angle lens gives me an inherently greater depth of field than a standard lens. Having my lens manually set to a predetermined focal distance eliminates the need to half depress the shutter and wait for the camera to focus. At a focal distance of around $2\frac{1}{2}$ feet with an aperture of $f/5.6$ (or smaller), my depth of field is roughly $1\frac{1}{2}$ to 5 feet. The depth of field covers my "universe" of 5 feet, resulting in focused, colorful photographs of any of those larger subjects that are suitable for wide-angle photography.

Some macrophotographers also prefer to focus manually. They do so using the focus ring on the lens or by using the focus lock feature. This preference is due, in part, to the fact that macro shooters use lenses with longer focal lengths, which are harder to handhold and keep steady than shorter focal-length lenses. If you cannot hold your camera steady, it can be difficult for the camera to achieve focus using autofocus.

**Lag Time.** Another potential focusing issue is digital lag. This is the amount of time that lapses between the instant you depress your shutter button and the moment the camera's image sensor actually captures the image. Lag times have become shorter as digital camera technology has advanced—but this delay can still cost you some great photo opportunities if the subject moves out of focus during the lag time. The digital lag time varies from camera to camera, with digital SLRs offering the shortest lag time. Because these cameras are made with buffers (a temporary storage space where the image data is sent before being written to the camera's memory card), you can shoot as fast as you can compose and depress the shutter control.

**Camera Movement.** Another common focusing issue involves camera movement. In this category, one problem that occurs is when a jerking motion is used to depress the shutter button. To avoid this, do not press the shutter button the way you would click your mouse; instead, apply gentle, firm pressure (think of squeezing the trigger on a gun, if you have ever done so).

Moving the whole camera as you fully depress your shutter button can also cause a picture to be out of focus. Hold your camera steady and with two hands. I place one hand on the camera and the other on my strobe (doing this also reminds me to make sure my strobe is properly aimed from shot to shot).

**Subject Movement.** Cameras aren't the only things moving in underwater photography—most of the time, your subjects will also be in motion. To maintain focus, this means you'll need to select a shutter speed that is fast enough to freeze the subject's motion in the frame. The faster the subject is moving, the faster your shutter speed will need to be.

## Do not press the shutter button the way you would click your mouse.

**Evaluate Your Results.** If you create an out-of-focus image, make an analysis and correct your mistake. If only a portion of the image is not in focus, either you misjudged the distance from the lens to the subject or the camera automatically focused at the incorrect distance. If the unsharpness affects the entire image, camera movement may be to blame, your shutter speed may have been too slow, or you may not have allowed enough time for the camera to autofocus before taking the photo.

### EXPOSURE

Exposure occurs when light reaches a light-sensitive medium and produces an image. A correctly exposed image is neither too light (overexposed) or too dark (underexposed). (Overexposure and underexposure can both be used intentionally for creative effect. However, we will

be using the terms to refer to images that are overall too dark or too light.) The aperture, shutter speed, and ISO setting each affect how much of the available and/or aux-

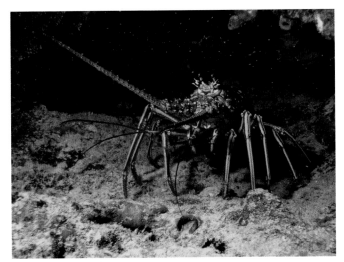

An underexposed image.

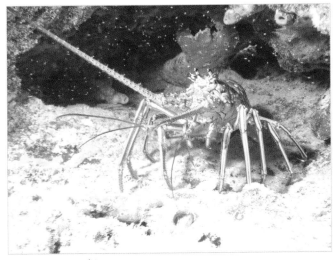

An overexposed image.

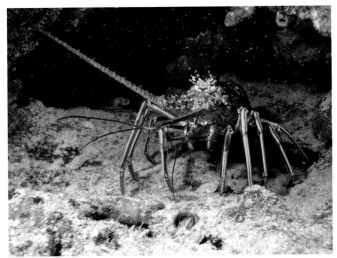

A correctly exposed image.

iliary light in the scene is recorded in each image, so these will be our basic controls for ensuring optimal results. (*Note:* When adding light, the power setting and light-to-subject distance of the auxiliary source will be additional controlling factors.)

**Aperture.** On pages 32–33, we looked at depth of field and the role the lens aperture plays in achieving sharp focus. Of course, the size of the lens opening also plays a role in determining exposure. Larger apertures admit more light and are represented by smaller f-numbers (*e.g.,* f/2.8). Smaller apertures admit less light and are represented by larger numbers (*e.g.,* f/16).

**Shutter Speed.** Shutter speeds (the amount of time the shutter stays open) are measured in seconds or fractions of seconds. When a "fast" shutter speed is selected, the shutter allows light to strike the image sensor only very briefly. For example, because it is half as long, a shutter speed of $\frac{1}{100}$ second allows half as much light to strike the sensor as a shutter speed of $\frac{1}{50}$ second—and so on.

**ISO Setting.** ISO settings are yet another component of the exposure system. The higher the ISO number, the

*TECHIE TALK*
## NOISE

The term "noise" ("grain" in the film world) refers to visually discernable specks that become more pronounced in prints—especially larger prints. In traditional photography, this can be caused by using high-speed (high ISO) film, which is manufactured using larger "chunks" of light-sensitive silver halide. To avoid graininess use a slower speed film. In digital photography, a similar problem occurs when using high ISO settings. To avoid noise, I recommend sticking with an ISO of 200 or less.

*A digital image displaying a high level of noise.*

more quickly the sensor reacts to the light striking it. Therefore, if you are shooting in a dark place, you may want to use a higher ISO, since less light will be needed to achieve a correct exposure. (*Note:* The trade-off for using a higher ISO is the increased appearance of noise—a speckled, grainy pattern—in your images. This is becoming less of a problem on the latest digital SLRS, but is still an important consideration that makes it worth shooting at a lower ISO setting as much as possible.)

**Exposure Techniques.** Just as there are techniques that can be used to ensure sharp focus, there are a few things we can do to ensure the best-possible exposure. For years, photographers have relied upon the "sunny 16" rule. This rule states that on a bright sunny day, with sun's light directly reflecting off your subject, you can set your aperture opening to f/16 and select the shutter speed that is the closest inverse to your ISO setting. For example, if you set the aperture to f/16 and chose an ISO setting of 100, you would select a shutter speed of $\frac{1}{100}$ second (or the closest available shutter speed, which is usually $\frac{1}{125}$ or $\frac{1}{90}$ second). Ideally, this will result in a correct exposure.

However, because best-case scenarios don't always pan out, we can also bracket our exposures. This means producing multiple images at slightly varying exposure settings to improve the odds of achieving one perfect exposure. For example, on a cloudy day, the photographer has less available light to work with. Therefore, to obtain a correct exposure, he might choose a larger aperture (*e.g.,* f/11) to allow more light to enter the camera than when shooting with the sunny 16 rule. Or, he might decide to use a higher ISO setting (*e.g.,* 200) or a slower shutter speed (*e.g.,* $\frac{1}{50}$ second), both of which would also allow more light to record in the image.

I should also note at this point that it is a common practice in underwater photography to employ an artificial light source to supplement the existing light, restoring colors that are absorbed by the water column as our diving depth increases. This offers another exposure control; you can change your exposure by adjusting the power settings on your strobe or changing your strobe-to-subject distance. We'll look at this in more detail on pages 44–46.

**Reading the Light.** So far I've spoken mainly about the science of exposure. However, the photographer's ability to read light also plays an important role in achieving a proper exposure.

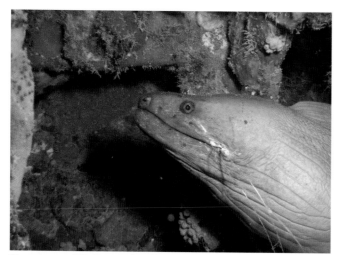

Shooting at f/5.6 provides the correct exposure.

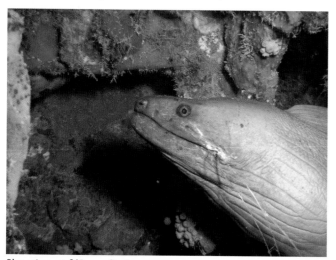

Shooting at f/8 results in a one-stop overexposure.

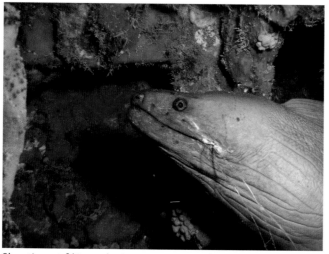

Shooting at f/4 results in a one-stop underexposure.

FACING PAGE—The dive boat and its exit ladder above the large stand of elkhorn coral gives a sense of scale to the coral.

If you've never consciously tried to read ambient light, try the following experiment. Take a break from reading, grab your camera, and walk outside. Note what type of day it is, sunny or cloudy. Note the available light and notice how it reflects from a given subject (*e.g.*, a car or a tree). Walk around the subject and observe how the light changes as you walk. If you do this when the sun is out, you should notice a difference in how your subject looks as your relationship to the sun changes. This change reveals an important truth about photography: in some instances you can change the existing lighting conditions by changing your position in relationship to your subject. As you are walking and noting the effect of the light on your subject, think about how you might adjust your camera's exposure settings to get a correct exposure.

If you did not have the ability to read light before, you do now. During a dive, the ambient light will not change dramatically unless your depth does, you enter into overhead environments, or are looking into coral recesses. Oc-

casionally the sun may be obscured by clouds. In such cases, you will need to remember to change your exposure settings. Generally speaking, however, the ambient light will not change dramatically because of the short time of the dive. You can achieve different lighting results by changing your position, though, and it is a good idea to keep this in mind when you are shooting.

Note, too, that your subjects will reflect light differently and may also create a need to adjust your exposure settings. A silver-sided barracuda or permit will reflect light much more intensely than a black durgeon or Nassau grouper will. There will also be different reflective qualities to other elements, including negative space, in your composition. In order to achieve an optimal exposure, you'll need to consider all of these factors and adjust your ISO setting, aperture, and shutter speed (and/or flash setting and position) accordingly.

**Metering the Light.** We may also rely on technology to read the light for us. When metering, the center-weighted light meter is my pick. As the name suggests, these meters take a reading from the central area of the frame. Matrix meters, another popular option, measure light from numerous areas throughout your frame, breaking the image down into discrete cells of information. This data is then compared with an internal database of lighting conditions to produce the best-possible exposure. Spot metering is also popular; it is similar to center-weighted metering but measures a much smaller area within the center of the frame. If your camera has metering capabilities, you can review your manual for additional information and available settings.

**Reciprocity and Exposure Values.** When refining your exposure settings, it is important to understand that there is a reciprocal relationship between apertures and shutter speeds. This means that you can quickly compensate for an increase in one setting by decreasing the other setting (and vice versa). For example, imagine you were taking a photograph at f/8 and 1/125 second; if you wanted to increase the depth of field, you could decrease the aperture one stop to f/11 and increase your shutter speed one stop to 1/60 second to maintain the exact same exposure. If you wanted even more depth of field, you could reduce your aperture by two more stops and instantly compensate by using a shutter speed that is two stops longer. This same principle can be applied in cases where we want to use a

faster shutter speed to stop action; we can compensate by selecting a larger aperture and still maintain the correct exposure.

This reciprocity is a good thing because it allows us to make adjustments quickly without having to meter the scene each time. After all, we are often on vacation when taking underwater images, and we want to keep things simple and relax! We're not on vacation yet, though: so let's put in just a little bit of effort into understanding how we can finesse our exposures to produce a great image that is neither too dark or too light.

Our first step on this journey is to investigate the concept of exposure values. Simply put, exposure values are a series of numbers that serve as a shorthand notation for all combinations of shutter speed and aperture. Understanding how these work will help you to successfully bracket your images and increase your odds of imaging success.

Let's revisit the sunny 16 rule to gain an understanding of how exposure values (EV) work. You might recall that the Sunny 16 rule states that on a sunny day, you can set your aperture to f/16 and select a shutter speed that is as close as possible to the reciprocal of the ISO number (*e.g.*, an aperture of f/16, and ISO setting of 100, and a shutter speed of $\frac{1}{100}$ second). Because this is our starting exposure, we will assign it a numerical value of zero (so this will be EV 0 [exposure value zero]). (*Note:* On an exposure chart, this exposure is about a fifteen—but this is our book, and I want to keep things simple so you can grasp the concept.)

Every exposure combination that allows the same amount of light to strike the sensor will have the same EV value. For example, the following three examples are all EV 0 "sunny day" exposures. (*Note:* Your camera may not have these exact shutter speeds. Many don't. In this case, use the closest neighboring shutter speed [*e.g.*, use $\frac{1}{125}$ or $\frac{1}{90}$ second instead of $\frac{1}{100}$ second].)

$$f/22 + \text{ISO } 100 + \tfrac{1}{50} \text{ second}$$
$$f/16 + \text{ISO } 100 + \tfrac{1}{100} \text{ second}$$
$$f/11 + \text{ISO } 100 + \tfrac{1}{200} \text{ second}$$

Looking back to our base exposure (an aperture of f/16, and ISO setting of 100, and a shutter speed of $\frac{1}{100}$

Snapper are schooling fish. In this instance, they are near a structure and facing into the current.

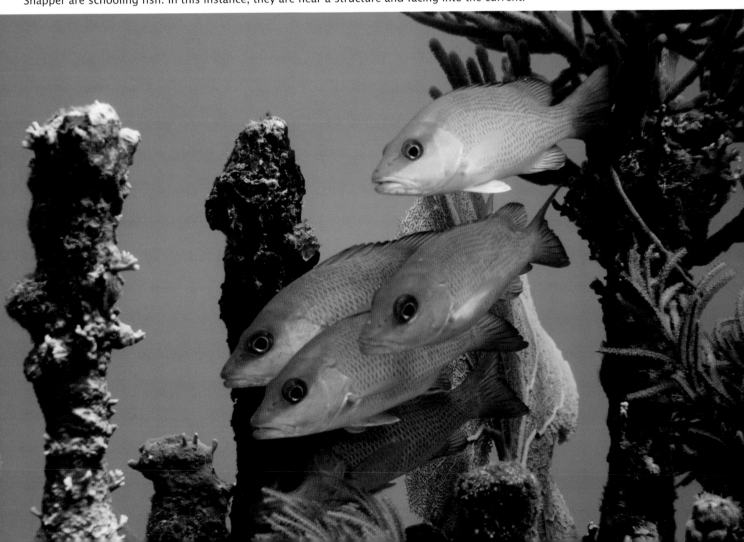

second), let's suppose that we wanted to open up the aperture to allow more light to strike the sensor. If I select an aperture of f/11, I am allowing twice the amount of light to enter the lens (the aperture size doubles every time you open up a stop). Because we have added light to the exposure, the exposure will be assigned a positive number. Because we increased the light by one f-stop, we will call this EV 1. If we wanted to allow less light to enter the camera, we could choose f/22 as our aperture. This setting would allow half as much light to enter the lens as f/16. Because the light is reduced one stop, we'd now be at EV −1.

Using these three apertures (f/11, f/16 and f/22) to take three photographs would yield three different exposures. One would be "correctly" exposed (EV 0), one would be overexposed (EV 1), and one would be underexposed (EV −1). One of these exposures should render the scene in an acceptable manner.

Let's step back a minute. The topic of reciprocity was introduced on page 40 so that we could consider exposure values. You learned that equivalent exposures could be obtained using the reciprocal nature of apertures and shutter speeds. At that point, a light bulb may have gone off. If it didn't light up then, it will come on now: we can also manipulate the ISO setting to finesse our exposures. Let's take a look at how it is done.

If you want to use the sunny 16 rule but don't have an 100 ISO setting (or ISO 100 film), what do you do? Well, remember that the higher the ISO rating, the faster the the image sensor will react to light. ISO 100 is twice as fast as ISO 50. Therefore, if you want to shoot at ISO 50 instead of ISO 100, you would need twice as much light to achieve the same exposure. What would happen if you chose an ISO of 200? Well, ISO 100 is half as fast as ISO 200, so you would need only half the light to obtain the same exposure.

Equating this to exposure values is easy. There is one stop of exposure value (the total amount of light recorded is either halved or doubled) between a given ISO and its nearest neighbor. For simplicity's sake, let's say ISO 100 is EV 0. I know that ISO 200 is one stop faster than its nearest neighbor, so its value will be EV 1. Similarly ISO 50 is one stop slower than ISO 100, so it's value will be EV −1.

Let's put this together using the sunny 16 rule as an example. If I can't work at ISO 100 (at an aperture of f/16 and a shutter speed of 1/100 second), then I could use another exposure setting, like f/16 and 1/200 second at ISO 200 (1/250 second can be used if your camera doesn't have a 1/200 second shutter speed). ISO 200 is twice as fast as ISO 100, so make an equivalent exposure, I kept the same aperture but used a shutter speed that is roughly twice as fast as 1/100 second. Like the original (f/16 at ISO 100 and 1/100 second), our new exposure is EV 0. In other words, the exposure should theoretically be right on—neither too light nor too dark.

But suppose, still shooting at ISO 200, that I wanted to shoot at f/22 to ensure more depth of field in my image? How could I produce an equivalent exposure? Well, using f/22 allows half as much light to enter the camera as f/16, but I could compensate for this by doubling the ISO speed to 400 or using a longer shutter speed (1/100 second instead of 1/200 second). This, too, would result in a "correct" exposure and would therefore have an EV of 0.

## Which variable you change will depend on what you want/need to do—or can do.

Under Sunny 16 Rule condition, what if I wanted to use f/22 for greater depth of field and I *did* have an ISO 100 setting? Well, if I use an aperture opening of f/22 and ISO 100, I'd use a shutter speed of 1/50 second (or the closest equivalent on most cameras, 1/60 second) to achieve the correct exposure (EV 0). Here's why: choosing a smaller aperture produced an exposure of EV −1. To compensate for the decreased amount of light being allowed to enter the lens, I used a slower shutter speed to allow more time for light to enter the lens (EV 1). Overall, this results in EV 0 ([EV −1] + [EV +1] = EV 0). I now have a correct exposure and have chosen settings that allow more of the foreground and background to be acceptably sharp.

Which variable you change will depend on what you want/need to do—or can do. Faster shutter speeds help freeze action. If I have a moving subject, I will want to stop it and correctly expose it. To do that, I'd keep my faster shutter speed and would compensate by using a

larger aperture. With flash (see below), shutter speed also governs the exposure of the water column or background's exposure. *(Note:* Using a faster shutter speed also renders blue water a deeper hue.)

You can now make any kind of exposure you need given the available light. You have the recipes! Are you ready to take this underwater? Or do you need a couple of aspirins? Well, we are not quite ready to head underwater yet—but read on and we'll get there soon!

**Artificial Light.** When you need to add light in your underwater scene, an external strobe is better than a built-in flash. Strobes are capable of producing light that is balanced with the color temperature of sunlight. They generally have more power than an on-camera flash. Because they are mounted to the camera via a tray-and-arm assembly, they are farther from and on a different geometric plane than the camera's lens, helping to reduce backscatter.

Strobes can also can be purchased with different angles of coverage, so be sure the strobe you are considering has an angle of coverage that is equal to or greater than your lens's widest angle of view. For example, if I am using a wide-angle lens and its angle of view is 90 degrees, I want to buy a strobe with a coverage angle of at least 90 degrees. ( *Note:* A diffuser is a nice accessory for a strobe. It fits over the face of the strobe, spreads the light outward, and softens the light. This increases the light's angle of coverage, but decreases the output by one stop.)

Before you purchase a strobe, there are additional factors you should consider. What powers the strobe? If it is battery-powered, how many pictures can you take before it runs out of power? What is the strobe's recycle time? How is it going to connect to and/or communicate with the camera?

*TTL Capability.* In my experience, if all of the elements in the frame reflect the same amount of light, then TTL is a good marriage between the camera and strobe. You may also achieve the desired exposure if the whole subject reflects the same amount of light and fills a great percentage of your frame. Unfortunately, my experience is that there is usually a huge difference in reflectivity between subjects and other elements in my frame—so, for me, TTL technology is not a mandatory feature when looking at a flash or camera system.

I am, however, an advocate of using TTL flash when doing macrophotography. First, in this type of photography, your strobe-to-subject distance is very small, making it all too easy to overexpose your image when using manual strobe power. Second, in macrophotography, you are less likely to be faced with extreme differences in reflectivity. I do not shoot a lot of macro, but I do use TTL strobe when doing so.

*Bracketing Revisited.* I prefer bracketing to using TTL technology. Earlier in this chapter, we discussed bracketing exposures by changing the aperture. Though this option is quick and easy, the depth of field is affected with every change—and there may be times when you do not want to sacrifice that great depth of field by using a larger aperture opening. When adding light, another option is to change the power setting on your strobe—unless the strobe is at full power, in which case the only change you can make is to shed less light on your subject. (Pun intended.)

The quickest option, when shooting with off-camera strobe, is actually to change the strobe-to-subject distance. If you are handholding your strobe or can quickly disconnect it from its arm or tray, this method also allows you to place your light exactly where you want it. ( *Note:* You can

## TECHIE TALK
# BACKSCATTER

"Backscatter" is a term that refers to particulate matter that is illuminated by flash and appears in your image. The light reflects from the particles, through your lens, and onto your light-sensitive media. You capture only the reflections of the particles, not the material itself. As mentioned earlier, having an external strobe mounted away from and on a different geometrical plane than the lens helps reduce backscatter.

Shooting in clearer, cleaner water can reduce the likelihood that your images will be affected by backscatter. Reducing your distance from the subject will help, too. Getting closer reduces the amount of turbid water between you and your subject. If there are a million bits of particulate matter in the water and you are four feet from your subject, there will only be half a million bits of particulate matter between you and your subject if you are two feet away.

 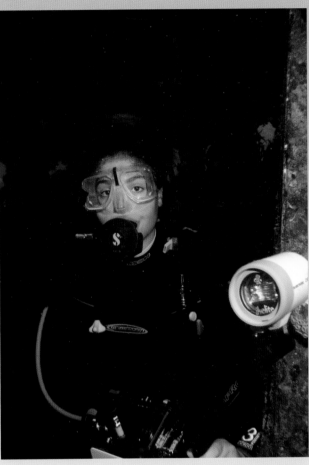

LEFT—*Backscatter can be a royal pain! Its presence in an underwater photograph has been the ruination of many otherwise great images that end up in the trash. This shot was taken with on-camera flash and shows backscatter.* RIGHT—*This shot was taken with an off-camera strobe and shows less backscatter.*

also purchase strobe arms and clamps that allow you, to a point, to change the strobe-to-subject distance without removing and handholding the strobe.)

When bracketing your exposures, use the method that is easiest for you, while keeping any trade-offs in mind.

*Putting it All Together.* When shooting underwater, if we want to capture color in our images, we must work within a limited universe that extends only five feet from us. This is because of the high absorption of color by the water column. Light travels from the strobe, to the subject, and back again to the camera lens. If that light travels even ten feet, we will start to lose the saturation in the red tones. In underwater photography, getting close can mean getting a much better shot.

So let's imagine we are shooting in open, clear water on a bright, sunny day. Set your strobe at half power and fit it

The flash was placed about two feet from this fish.

The flash was placed about four feet from this diver.

with a diffuser to soften the light and help prevent hotspots that can be caused when the strobe is not properly aimed. From this point, I suggest starting with an exposure of f/5.6, an ISO setting of 100, and a shutter speed around $\frac{1}{100}$ second. Though other exposure settings would yield the same exposure value, I've adopted these as my starting point because I prefer the rich blue tonal value I get in the water column when using $\frac{1}{125}$ second shutter speed. Also, I feel that flesh tones are best rendered when using an aperture of f/5.6. From here, if you are working within your universe of five feet and determine these exposure set-

tings are a little off, you should only need to tweak one of them by one or two stops, up or down, to get just what you want. From this starting point, you can bracket the shot by opening up a stop to f/3.5 (or f/4 if that is the "nearest neighbor" on your camera) and stopping down to f/8.

Some digital cameras do not offer an aperture smaller than f/8. In that event, you'd need to bracket for less exposure in a different way. My method of doing so is to reduce my strobe power or increase the strobe-to-subject distance. For example, I dive mostly in clear water and on sunny days, generally at depths of around thirty feet. For this, I use the sunny-day white balance preset (see page 48 for more on this) and, with my current camera system, start at an exposure of f/5.6 + ISO 100 + $\frac{1}{125}$ second with a half-power, diffused strobe. When I dive deeper, to depths of one hundred feet, I use a full-power diffused strobe and may use a shutter speed of $\frac{1}{60}$ second and/or an aperture of f/4. In any form of semi-overhead or overhead environment, I really open up and use a shutter speed slower than $\frac{1}{125}$ second and an aperture larger than f/5.6. If necessary, I use a full-power strobe and remove the diffuser. (*Note:* For practical purposes, and some technical reasons, underwater photographers normally use a shutter speed of $\frac{1}{60}$ second or one in the neighborhood of $\frac{1}{100}$ second (e.g., $\frac{1}{100}$ or $\frac{1}{90}$ second) for their everyday shooting. When shooting macro and very close to the subject, a shutter speed of up to $\frac{1}{500}$ second can be used—as long as your strobe will synchronize at that shutter speed.)

When shooting, I want to have my camera set up and ready to grab a shot when the opportunity presents itself— I may not get another chance. Therefore, I aim my strobe to intersect with the lens axis about three feet in front of me. This is a bit over halfway to the end of our universe. When using a standard lens to photograph fish, a two-foot lens-to-subject distance works well. Most reef fish— grouper, parrotfish, and other fish of that size—will fill a pleasing percentage of the frame when photographed from that distance. Basically, if you are close enough to reach out and touch the fish, you are close enough to photograph it. When photographing divers with a standard lens, four feet is a good distance. While you will not be able to get the whole body of a diver in the frame, a working distance of four feet or so will grab you a nice head-and-shoulders shot that fills a pleasing percentage of the frame.

If you set the beam angle of your strobe to intersect with the lens axis at three feet, it will cover from under two feet to beyond four feet—meeting your needs for photographing both subjects.

How do I determine two, three, or four feet underwater? I use a crude method: my arm length. For me, one arm length is just over two feet. Go ahead and measure yours and then use that as your gauge. If you hold out your arm in front of you often enough, you will get a sense for an arm's length of distance.

As you shoot, you can tinker with the aim of your strobe or its distance to the subject—just remember that your eye and lens see apparent distance but your strobe does not. When aiming your strobe, aim it slightly beyond where you see your subject. You can then check your LCD to determine if your aim was off or if the image is grossly under- or overexposed.

I try to remember that I am using the strobe only to restore colors that are lost through absorption by the water column. Your goal should be to gently bounce the strobe's light off of your subject. One photographer I know likens the use of the strobe to using a velvet hammer. I think of it as splashing the subject with light, not fire-hosing it. When used correctly, the viewer of the image should not be able to tell a strobe was used. Your strobe should not be the equivalent of a Mack truck barreling down a North Carolina highway at 2 A.M. with its halogens glaring!

*Guide Numbers.* If you know it, you can also use your strobe's guide number (GN) to calculate your exposure. For example, if my strobe's guide number is 33 and I am three feet from my subject, I can divide the subject-to-strobe distance (three feet) into the guide number, and the result will give me my aperture setting. In this case, I would divide the guide number of 33 by 3 and determine that our aperture should be f/11. Another way to work with your guide number is to select the aperture and then divide that into the guide number. Doing so will tell you the distance you want to be from your subject for a correct exposure. For example, if our aperture was f/8 and our guide number was 33, our ideal strobe-to-subject distance would be roughly four feet. Note that guide numbers are usually based on an ISO setting of 100 and are a way of measuring a strobe's power output and on land. In some cases, you would reduce the GN value by ⅓ to ½ when working underwater.

**Dynamic Range and Exposure Compensation.** The majority of digital cameras that are being taken underwater do not have an extraordinary dynamic range (the number of possible tones from white with detail to black with detail). Most have a tendency to wash out the detail in the highlight areas of your picture. They do better in the shadow areas. The exceptions to this are the very high-end and high-dollar digital SLRs, but most of us regular guys are not toting those cameras.

> Most have a tendency
> to wash out the detail in the
> highlight areas of your picture.

One would think that the camera settings that affect exposure—the ISO, aperture, and shutter speed settings or strobe power/distance—could be tweaked to prevent this problem. Nope. It helps, but it does not solve the problem. If your camera does not offer manual controls, I suggest using the exposure compensation settings to underexpose by a fraction of a stop—say –.3 stop. As of this writing, this is the only workaround I've found to help with this issue.

When you are looking through your viewfinder or at your LCD and see lots of highlights or areas of great reflec-

*TECHIE TALK*
### DYNAMIC RANGE

This is the total range of tones that can be captured, displayed, or perceived by a device (or person). Our eyes have a large dynamic range. Film and digital cameras have lower dynamic ranges—meaning your eyes can see colors and detail that your camera can't. If a scene you are photographing contains a range of tones that exceed the dynamic range of the camera, your image will suffer a loss of detail in the shadows, highlights, or both. Middle-range digital cameras do a fair job with shadow areas but have a tendency to "clip" the highlights, meaning, they can fail to show detail in light areas of the photograph. Therefore, if I am going to err at all in my exposure, I'd rather err toward underexposing than overexposing. I can often recover shadow detail in postproduction—but once I've "clipped" my highlights, that data is gone.

These photos were created to illustrate extreme examples of white balance and how different white balance settings will affect colors. The first image (left) was shot using the automatic white balance setting. The second image (center) was created with the fluorescent white balance setting. For the third image (right), I chose the tungsten white balance setting.

tivity, be careful about how much light you shine on them. Alternatively, you can try to compose your image so those areas are cropped out of the frame.

**White Balance.** When films are manufactured, they are made with a certain color balance or bias or color temperature in mind. So long as we shoot in the lighting conditions that our film is made for, the colors in our images should be rendered accurately. Digital cameras, on the other hand, use algorithms that determine what reds, greens, and blues should look like under a given light source. We can use the automatic white balance, select a preset (*e.g.*, incandescent light, cloudy day, etc.), or create a custom white balance setting. Some cameras also allow the option to white balance for a certain color temperature (measured in degrees Kelvin) or for flash.

For day in, day out shooting, automatic white balance is the one idiot-proof setting I will opt for. This is not set in stone, though. While the automatic feature works well with most cameras, it may result in a slightly different white balance being used from shot to shot, and you do not know ahead of time whether you will be satisfied with the results. It does not hurt to experiment with your white balance choices in different ambient light conditions or water colors. If you do, try to log what the lighting conditions were, what the visibility was, and what tint, if any, the water column had. Note whether the white balance setting worked or not.

On days when I dive in deeper and darker—yet clear blue—water, my camera's cloudy day white balance setting gives me good results. I also use the sunny day white balance setting when working in shallower water on bright and sunny days.

Using the auto feature, sunny day, or cloudy day option should get you in the right ball park. You will find that your white balance options will produce different results from camera to camera, so the best bet is to experiment until you can make an educated guess as to what works best in your shooting conditions and with your camera system.

**Fine-Tuning the Color and Exposure in Postproduction.** In post-capture, you can bring out details in shadow areas that are a bit underexposed. It is nearly impossible to restore detail in blown-out highlight areas. Therefore, if I am going to err with my exposure, I'd err toward underexposing. Color balance is another quality that is relatively easy to adjust in postproduction; if your white balance is a little off on an otherwise great shot, this is an important option to keep in mind.

There you have it: a step-by-step look at achieving a properly exposed image underwater. As mentioned early in the chapter, however, there are other important components involved when building an acceptable image. Let's move on to discuss composition.

## COMPOSITION

Composition is the arrangement of the objects or elements in the photograph. The subject is part of the composition, as is the foreground, background, and any other object in the frame—as well as any negative (empty) space. For instance, an underwater photograph could have a turtle for its subject, coral in the foreground, coral in the background, and the water column would be the negative space.

There are "picture takers" and "image makers." I can't remember where I heard that or read that, but I think it is a profound statement. If we have a camera and use it to take snapshots, we are picture takers. To be an image maker requires more technique than technology. Simply purchasing a better camera is not likely to make you a better photographer. I once had a camera repaired. Months later, I ran into my repairman, and he asked how the cam-

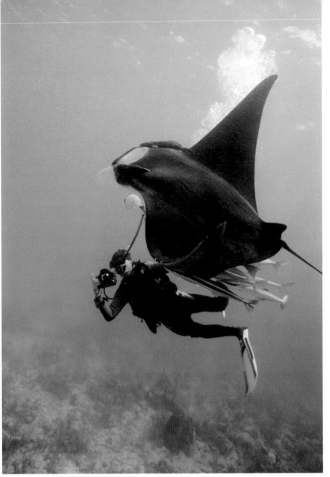

BELOW—This is a basic composition including a subject, foreground, background, and negative space. RIGHT—In underwater photography, good composition is somewhat dependent on being in the right place at the right time.

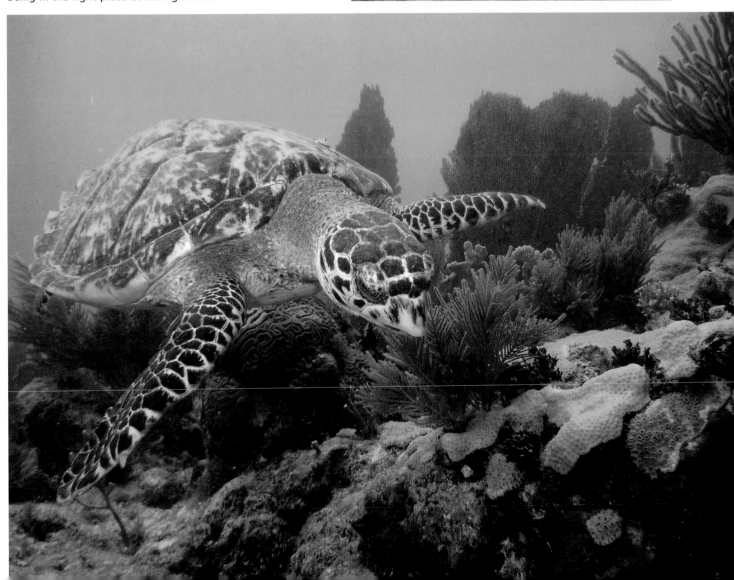

LEFT—This is the standard tourist's "I was there" composition. RIGHT—The same subject appears in this image, but the composition allows us to see more of the scene and to gain a sense of all that is happening.

era was working. I remarked that I thought he'd fixed it and he said he did. I said, "Well, the camera does not take any better pictures now than before you fixed it!" I hope you are getting the picture here.

In composing your image, the way you arrange the various elements in your frame "makes" the picture. A nicely composed photograph can evoke emotion or tell a story. It can also help the viewer feel a connection to the subject in the photograph.

Some photographers are creative in their use of focus, lighting, and exposure, and those elements can add to their composition. Having a working understanding of focus, I know what in my frame will be (and won't be) in focus. Because I understand exposure, I can predict which areas of the framed scene will be properly exposed and which may not be. I also know which areas will be colorful and which will be void of color. This knowledge base gives me

the tools I need to create an effective composition.

Let's take a look at the difference between a snapshot and a well-composed image. I've just photographed my friend standing in front of the boat we dove from during our tropical vacation (see the photograph above [left]). It was a great trip, and we liked our dive operator, whose name was on the side of the boat. I was so excited to get the image that I only photographed my dive buddy. The image is in focus and is correctly exposed. My dive buddy is dead center in the frame and anyone can tell what the subject is. But what else is in it for the viewer? Not a lot unless they really like me and my buddy—or are divers and interested in seeing a picture of a guy and part of a dive boat in a tropical paradise.

Is there anything "wrong" with this image? No, not inherently or even technically. On the other hand, there is nothing remarkable about the image. The only story it tells

compose that image by photographing the fish broadside and dead center in the frame. This is called a specimen shot. Like this first image of my buddy by the boat, there's nothing "wrong" with such an image (if there were, we'd have to burn all the fish identification books!)—but there are also other ways to approach photographing a fish. By exploring these, we can make our images more exciting to view. (I should note, however, that none of the following tenets of composition are set in stone. These guidelines can help us achieve a more pleasing composition, but composition is ultimately all about creativity.)

Technical errors can and do happen. Here, we have a poorly thought out composition.

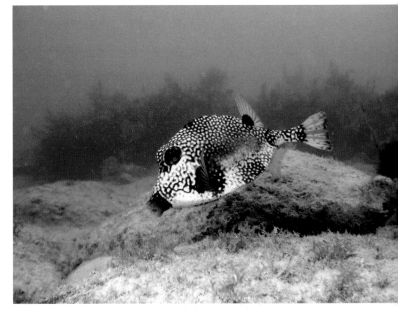

A specimen photograph of a boxfish.

is, "Hey, look, I am in a tropical paradise." That is a good story, but it would have been nicer if I had changed my position or moved my buddy so that I could capture more of what was going on. There were two subjects in the photograph. With my dive buddy centered, the primary subject commands the attention, with little emphasis placed on the secondary subject—the activity in the frame. In the second image (facing page, right), I paid more attention to the composition. The viewer now knows more about what the boat looks like and can see that the photo was taken after the dive, as my buddy is leaving the boat, not boarding it. The second photograph has action.

Fortunately, if we develop our compositional skills in the topside world, we can transfer them to the challenges of the underwater world. For example, being consummate underwater tourists and encountering fish, our first impulse may be to photograph every fish we see—and to

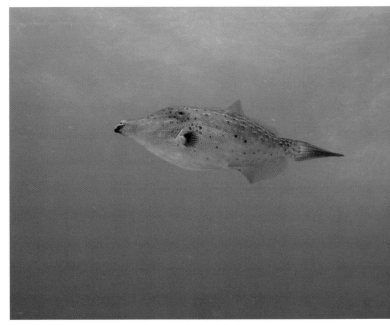

A specimen photograph of a scrawled filefish.

**The Rule of Thirds.** One of the guidelines photographers use to improve the appeal of their images is the "rule of thirds," which helps ensure a more dynamic placement of the subject. To use the rule of thirds, imagine a tic-tac-toe board superimposed over your viewfinder, then simply position your subject on one of the four lines or at one of the four points where the lines intersect.

So, does it make a difference which point the photographer uses when composing? Yes. You want to leave your subject—a fish, for example—room to move. Pretend for

A damselfish centered in the frame.

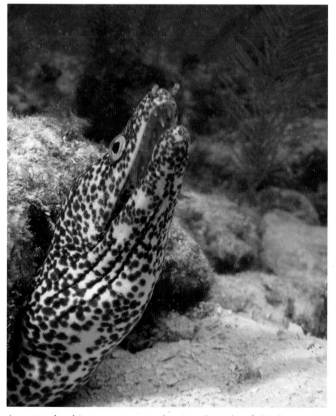

A spotted eel image composed using the rule of thirds.

a moment that you are viewing a photograph with a fish in it. The fish is moving from your left to your right. If you use one of the two intersecting points on the left side of the image to place your subject, then you've left your subject some empty space to move through in the frame. If you use either of the two on the right-hand side, then your subject has less room to move. The story is just beginning when the fish is "placed" at the left (swimming into the frame); it is ending when the fish is "positioned" at the right (about to swim out of the picture).

**Vantage Point.** Another transfer we take to the underwater world is how we look at things. We walk upright and tend to look at things straight ahead. Or when we are walking, we look down a bit. When diving, we are up off the bottom a distance and look ahead of ourselves, to the left or right, or down. The higher we are in the water column, the more of a tendency we have to look down.

As photographers, we see our subjects where we are looking. If you are looking down, then all the subjects you see will be below you, and in your quest to capture that subject before it escapes, you will take your photograph by shooting down. This is a common mistake. The way to prevent such a mistake is to dive lower in the water column

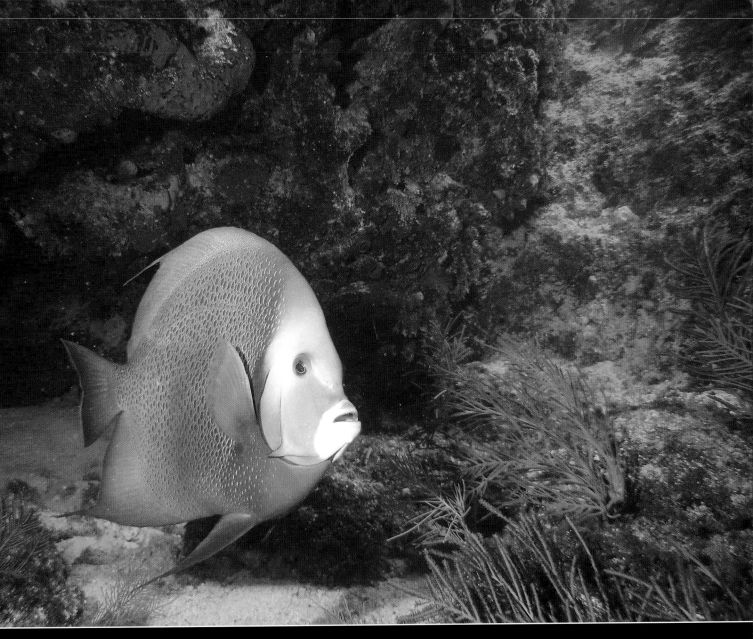

ABOVE—When a fish moving from left to right is captured at the left side of the frame, the viewer gets the sense that the story is just beginning. RIGHT—When the fish is moving from left to right and is positioned on the right side of the frame, the viewer gets the impression that the action is ending.

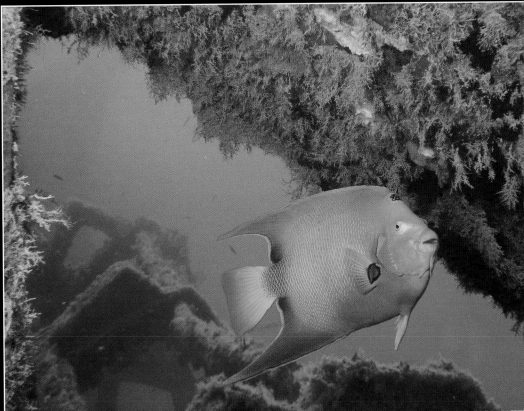

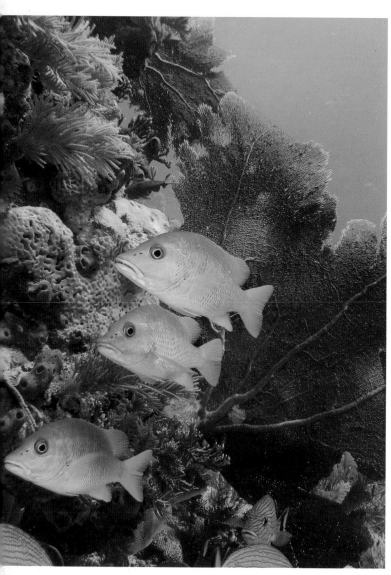

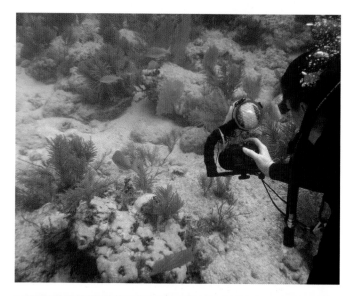

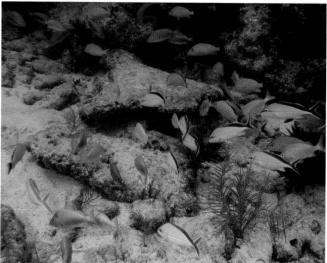

RIGHT (TOP AND BOTTOM)—These images are the results of shooting down. More pleasing compositions could have been made by shooting across at the subjects, which would have been better separated from the other elements in the frame. LEFT—Shooting across at your subject results in a better composition.

(keeping in mind your depth limits). Now you will be looking more ahead of you and to your left or right. You may even have a tendency to look upward. You will find yourself looking down only to check that you are not colliding with the bottom and to prevent damage to the corals. When diving lower in the water column, you are better positioned to make a nicer composition of your subject when you see it.

So an underwater rule of composition is don't shoot down at your subject. Why? Because it violates a topside rule of composition: separation. We want our subject to stand out from everything else in the frame so the viewer can easily identify the subject in the photograph. If you shoot down at your subject and it is obscured by the bot-

tom and its content, the subject can appear almost hidden.

Shooting upward at your subject is another way to achieve separation and can add some contrast in your image. When you are underneath your subject, it is almost—if not totally—separated from any surroundings other than the water itself. Negative space is added to the image, helping the subject gain prominence. Also, many fish have colors that contrast with or complement the color of the water column.

Shooting even slightly upward at your subject also conveys a sense of empowerment to the subject and can evoke emotion in the viewer and spark their imagination.

*Snell's Window.* When shooting in shallower water, the photographer often captures some of the surface of the

ABOVE—This image shows the result of shooting upward at the subject. RIGHT—Here is the photographer shooting upward.

BELOW LEFT—A composition that was designed without Snell's window. BELOW RIGHT—A composition including Snell's window.

These fish were photographed from behind, resulting in a photo of fish butts!

This is an example of a broadside photograph. Note that photographing the subject from this angle will allow you to include at least one eye in the image.

Most fish are narrow and do not fill much of the frame when photographed head on.

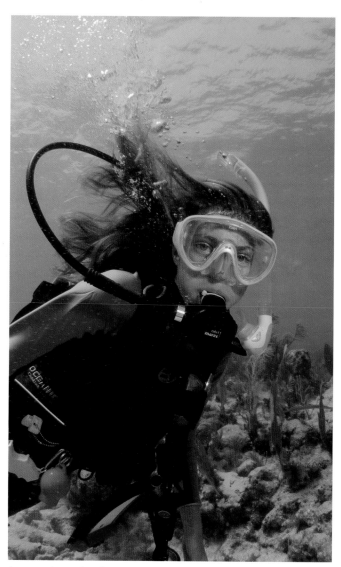
A snapshot of a diver, Heather. Compare this with the image shown on the facing page.

water in the image. The area of the surface that is visible in a photograph is called "Snell's window." I believe that Snell's window often adds a pleasing element to my underwater compositions.

**The Eyes Have It.** Another rule of composition in underwater photography is "the eyes have it." If the subject has eyes and you do not show one or both in the image, you have no image. When the viewer can look into the subject's eyes, a sense of connection can be created. This can lead to the stirring of an emotion.

When you are seeking to take a photo of a dive buddy that says more than "I was here," the eyes are also critical. Divers dive to see things; therefore, try to capture an image that includes both the diver and the subject that he or she is examining.

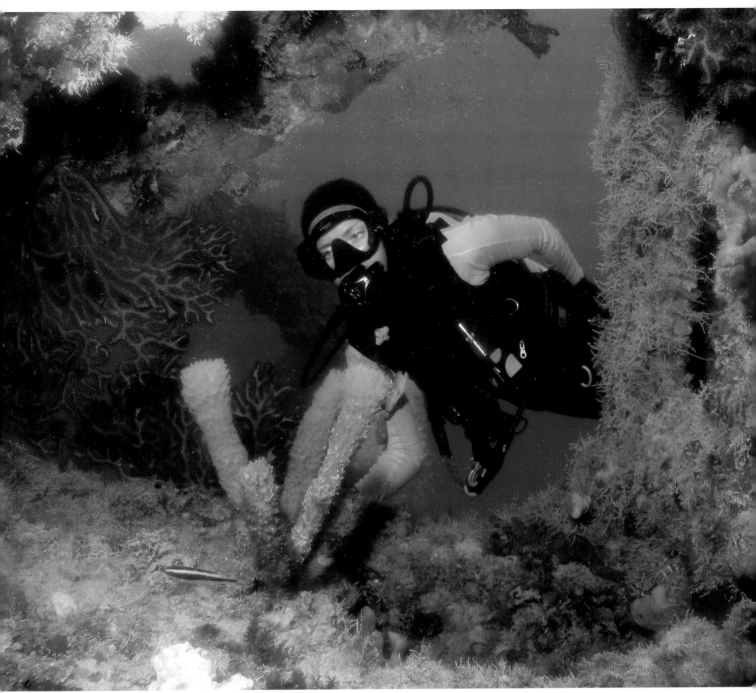

Here, the diver, Aja, is engaged and doing something. There is more of a story behind this image than there is in the previous shot (seen on the facing page).

**The Quartering Angle.** One of the most pleasing angles from which to photograph a fish is the quartering angle. This results when the fish is coming toward you and you capture an image in which the fish is shown not head-on or broadside but right in between. In this view, the fish appears to be interacting with the photographer and later, the viewer. In this rendering, we convey more of a feeling that an image was made than that a picture was taken.

In trying to capture a fish at a quartering angle or head on, you can wait for the fish to approach, but it does not occur often enough. Fish have a tendency to want to move away from you! A better approach is to position yourself ahead of the fish and then turn back to get the quartering angle. No cooperation from the fish is necessary. You will get the shot so long as it keeps moving in a straight line and in the direction it was coming from.

In this image, the subject was photographed from the quartering angle.

LEFT—In this example, the photographer made the quartering angle happen. The "tell" is that the tail is not curved as it is in the previous image. RIGHT—The photographer made this shot happen by positioning himself in front of the Atlantic spadefish then turning and shooting back toward the subject.

Occasionally you will notice a fish "dancing" in the reef—moving back and forth, turning left and right and up and down, but still occupying a small area of the reef. You can take advantage of this dancing to capture a quartering photograph of the fish as it makes one of its turns. This takes some patience and timing, though, and it will likely require more than one attempt.

**Contrast.** Contrast is another important component of creating effective compositions. Contrast can be achieved by including light and dark areas in the frame or by photographing a scene containing elements with contrasting or complementary colors. In a coral reef, for instance, you will find reds, blues, greens, yellows, oranges, maroons, and purples—to name just a few of my favorites.

RIGHT—A dancing boxfish. BELOW—These raccoon butterflyfish exemplify contrast in color.

**Framing.** Framing your subject using another element in the scene can also help to draw the viewer's eye to your subject and can improve the impact of the image. For example, you can frame your dive buddy's face looking through a ship's porthole or photograph a fish peering through a hole in the coral reef.

**Leading Lines.** Leading lines are another compositional element that can be used to draw the viewer's attention to the subject. The lines can be either literal (the

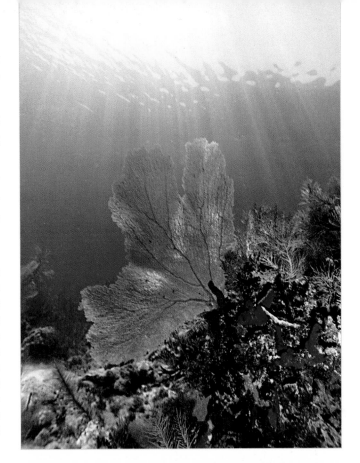

FACING PAGE—In a silhouette, contrast is almost everything. Such images are almost void of color; what is left is white light, a dark or black subject, and a blue water column. Here, we have a silhouette image of a statue of the Christ of the Abyss. To make this image, I positioned myself to be able to shoot straight up at my subject. My ISO was set to 100, and I used a $^1/_{125}$ second shutter speed with an aperture of f/22 (and no strobe). The small aperture opening caused the subject to be very dark and the fast shutter speed froze the sun's rays penetrating into the water column. RIGHT—The splendid colors of the scenic coral reef. BELOW—A spotfinned butterflyfish is framed by the eye of a Spanish anchor.

diagonal edge of a wreck) or implied (where your eye might move from a pictorial element in the lower-left of the frame toward a subject near the upper-right corner of the image). These lines do not have to be straight, which is a good thing, since there are no straight lines in nature.

**Keep it Simple.** When I am doing photo dives with my students, I teach them to begin building their talent in composition by photographing simple subjects. Photographing an inanimate subject eliminates one of the three things that can move. When you are first starting out, you may also want to start with a subject whose size is appropriate for the lens you are using. Photographing a single fish, a sea rod or sea fan, or a head of brain coral, for example, will allow you to employ some of the above-mentioned tenets. When you shoot enough frames of simple subjects, the compositional basics will become part of your photographic technique.

LEFT—The striped grunts are framed by a coral recess. BELOW—The first queen angelfish is easy to observe because of its position in the frame and the space it occupies, but the leading line of the wreck edge draws your eye to the second fish.

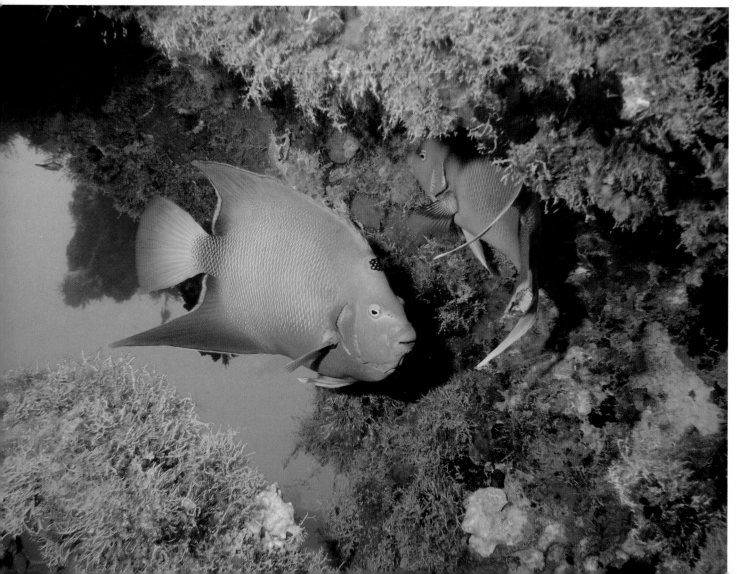

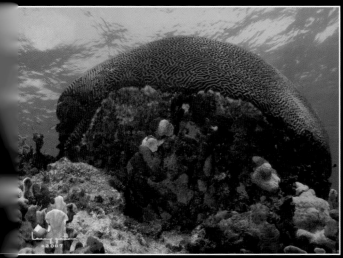

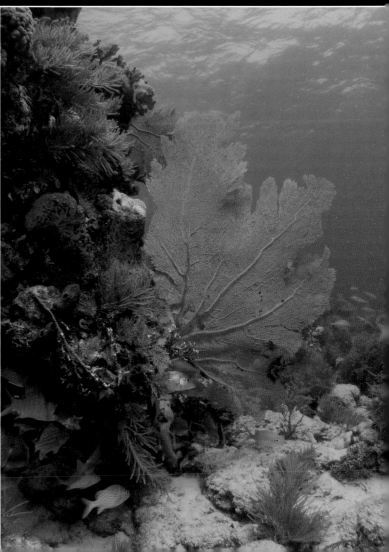

TOP—This is an example of a simple subject, an Atlantic spade-fish, with little else in the frame. ABOVE—Here is another exam-ple of a simple subject, a huge head of brain coral. It is relatively easy to photograph because it is a static subject. RIGHT—This image features a simple subject, a purple or common sea fan, with other compositional elements included (Snell's window and the orange elephant ear sponge).

Further, shooting simple subjects prevents your composition from becoming too busy. Try not to be too ambitious when learning to compose. You can have too many subjects in your composition. Also, be sure to scan the entire image area, from corner to corner. This will help you to crop out distracting image elements like incomplete subjects or incomplete secondary subjects.

**Portrait or Landscape Format?** When photographing scenic images on land, most of us shoot in the landscape format (so that the resulting image is wider than it is tall).

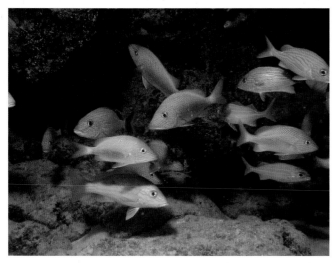 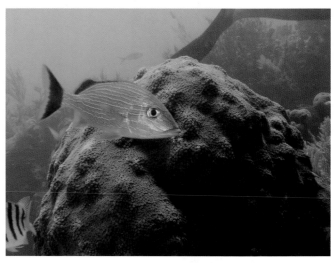

LEFT—This composition is too busy. The main subject, the fish, is difficult to discern because the viewer is distracted by the fish's neighbors, the direction they are facing, and the positions they are in. RIGHT—In my attempt to photograph a simple subject, a single fish over a head of star coral, I did not scan my viewfinder to look for distractions prior to taking the shot. As a result, we see not only the subject but a diver's fin and leg, part of a sergeant major, and the tail fin of another fish! A nicer composition would have been accomplished had I waited a few seconds!

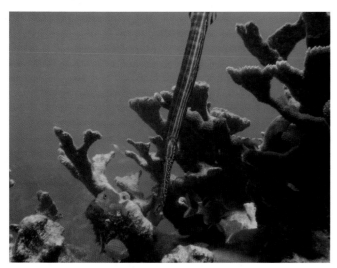 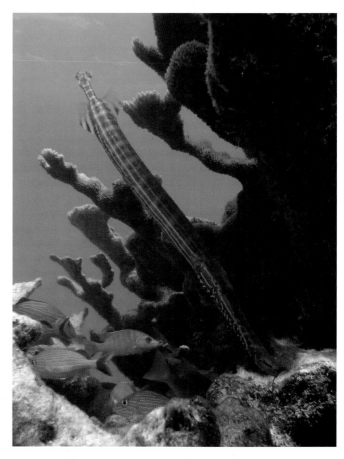

Compare these two images. With the subject in the position shown, the portrait format (right) is a more effective compositional choice than the landscape format (above).

ABOVE—An example of an image with no negative space. RIGHT—Designing your image with negative space often makes for a more pleasing composition.

BOTTOM LEFT—The subject's whole body is shown, but with little color. BOTTOM RIGHT—Capturing a closer view—a head-and-shoulders shot—renders the image with more color.

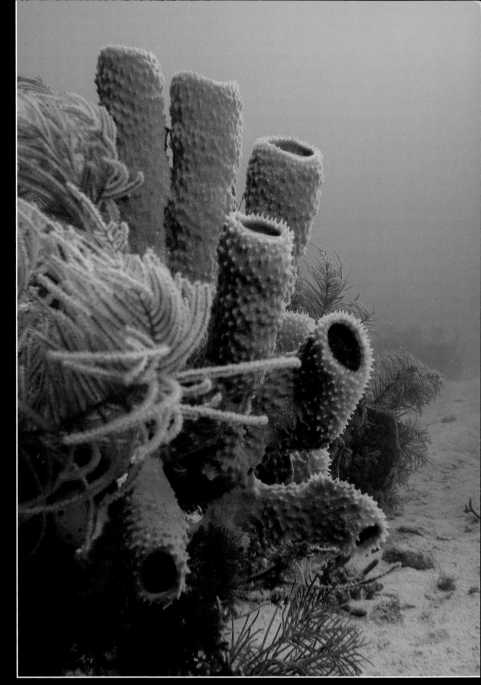

If you tip your camera 90 degrees, you will produce images in the portrait format. There are instances when it is more appropriate to shoot in the portrait format. A trumpetfish is a long, narrow fish that can swim horizontally through the water column—but it can also suspend itself and hang almost vertically. In instances when the trumpet fish is vertical in the water column it is more appropriate to use the portrait format.

When unsure as to which format to use, take a shot each way. You will determine one to be more pleasing than the other, depending on your subject's orientation within your viewfinder.

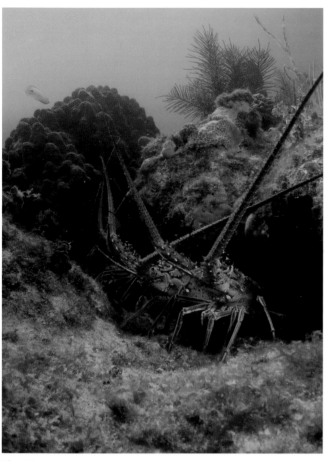
Shooting across.

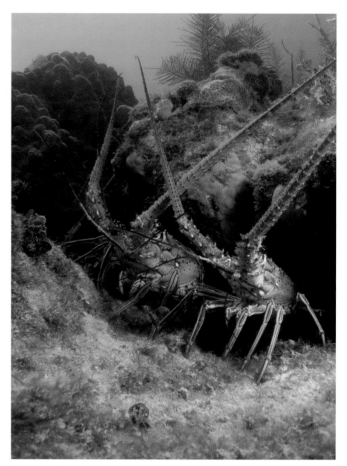
Getting closer.

Shooting down.

Shooting upward.

**Learn from Your Mistakes.** Now we are armed with some basic concepts of composition to help make more pleasing images—not only for ourselves but also for our viewers! In this section, you'll find a summary of the concepts and photo examples that show cause and effect. Granted, some of the images shown may be "acceptable," but you won't find any heart-stoppers here.

- Shooting down at your subject tends to make the subject merge with the background.
- Shooting from too great a distance results in either lack of color or a subject that does not fill a pleasing percentage of the frame.
- The inclusion of unintended objects in the frame is distracting and can ruin the image.
- Having too many objects or elements in the composition makes for a visually confusing image.
- Not using the correct lens for your subject can lead to a less than compelling composition.

You now have a working knowledge of composition and can transition from being a picture taker to an image maker. It is safe to move on to the fourth element of what goes into the making of a pleasing image: the subject.

### SUBJECT

Most images have a subject—a primary point of interest. I categorize underwater subjects into six groups (fish, other creatures, coral, reef scenes, divers, and wrecks or other man-made objects) and three sizes (small, medium, and large).

Fish.

Creature.

Coral providing a home to a Christmas tree worm.

LEFT—The late Jim Church called this type of photographic composition a "close focus/wide angle" shot; Howard Hall called it a "near-far" shot. It is a combination photograph, wherein you have two subjects: a near subject (a sponge) and a far subject (the diver above). The near subject is colorful and the far subject is in silhouette. To create this image, I used a wide-angle lens. I positioned myself close to and below the sponge then shot at an extreme upward angle. My camera was set to an aperture of f/22, and its shutter speed set to $\frac{1}{90}$ second with an ISO setting of 100. I used my strobe at full power. By making these choices, I was able to render the far subject in silhouette but record the color of the near object. The difference between the result shown in the image on page 60 and this image is that a strobe was used. FACING PAGE —Another example of the same technique, but this time with a wreck silhouetted in the background.

When we consider the four elements that comprise an acceptable image, the subject carries a great deal of weight. The size of our photo collection depends more on the variety of subjects we have photographed than on how we exposed or composed the subjects. A nice collection of underwater images will include samplings of all the above subjects—in good focus, correctly exposed, and nicely composed.

**Subject Size.** In an effective composition, the subject should fill a pleasing percentage of the frame. There is no hard-and-fast rule that dictates the percentage of the frame that the subject should occupy—but if my subject fills so little of the frame that I need to point it out to the viewer,

then I know I did not fill a pleasing percentage of the frame. If my subject fills the frame completely, it had better be a very compelling subject, as I've left the viewer with nothing else but that subject to view.

I believe the best lens for shooting reef fish and other swimming critters is a standard lens. It works for fish in the butterfly-size category up to the larger reef fish, like parrots and grouper, and for turtles, rays, sharks, octopi, eels, and lobster. It is also suitable for photographing head-and-shoulders shots of divers. It does not lend itself well to photographing entire reef scenes but works very well for photographing parts of the reef or individual coral growths such as sea fans, rods or whips, or various sponges.

TOP LEFT—This image shows too little of the subject. TOP RIGHT—This image shows too much of the subject. ABOVE—Here we see a pleasing percentage of the subject. There is no real rule that outlines the percentage of the frame a subject should occupy.

For photographing very small subjects, using a camera with a macro capability or selecting a macro lens is best. We need a lens that has a very close focusing distance to shoot these smaller subjects. It must also have a narrow angle of view if we want that subject to fill a pleasing percentage of our frame. For photographing large subjects, such as the mountainous star corals, a lens with a wider angle of view is the lens of choice. Do not use the digital zoom feature on your camera to "get closer" to the subject. When you use this option, the camera crops out portions of the image, reducing the image dimensions and restricting your ability to print larger images.

Below are three images of the same subject made with the three types of lenses that underwater photographers most commonly use. The first shot was made with a macro lens, the second was captured with a standard lens, and the final image was created with a wide-angle lens.

Now let's discuss photographing one of my favorite subjects: a diver. If I want my image to include the diver's whole body and all his equipment—and I want to work within a five-foot distance so that I can capture color—a wide-angle lens would be the best choice. A standard lens with its narrower angle of view is not going to afford me that ability. If I am equipped only with that standard lens and know its limits, then I would not try a full-body shot. Instead, I would make a nice head-and-shoulders portrait. If I only had a macro setup, I would probably not choose to photograph a diver at all. (As I write, I am hard pressed to think of a part of the diver that I would even attempt to shoot with macro!)

**Planning Your Subjects.** In our scuba classes, we are taught to plan a dive and then dive the plan. In underwater photography, it helps to plan what subject you want to photograph during your dive. Even though you can photograph other subjects when the opportunity arises, you will be more successful in your underwater photography if you know what subjects you are likely to encounter and how you would like to photograph them. Once you have a plan, you can select the equipment you need to best cap-

ture that subject. Having an action plan will also allow you to formulate some ideas about how you would like to compose the subject. A well-conceived approach will help you make the best of your time underwater. After all, we all have a limited number of dives at a destination and limited time during those dives.

## It helps to plan what subject you want to photograph during your dive.

When planning for your dive, you must go where your desired subject can be found or adapt and shoot what's there. One of my photography instructors was frustrated when his students would come to his course and want to take photographs of sharks—because he wasn't teaching in shark-infested waters! If I wanted to photograph sharks, as of this writing, I'd do some research and dive the Bahamas. For great numbers of fish life, I'd dive the Florida Keys. For photographs of turtles, I'd dive the Hawaiian Islands. For manta rays, I'd head to Yap in Micronesia. For lush gardens of corals and photographs of reef scenes, I'd dive Bonaire in the ABC islands. For a photograph of a whale shark, I'd head to Utila or Honduras. Obviously, these locations are not the only place in the world's oceans

These photos illustrate the proper use of the lens and the proper part of the subject for each lens type. The first image (left) was created with a macro lens. The second (center) was shot with the standard lens. For the third (right), I used a wide-angle lens.

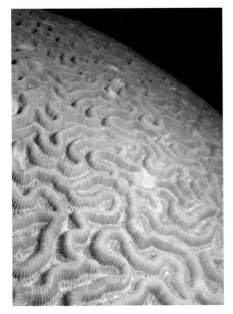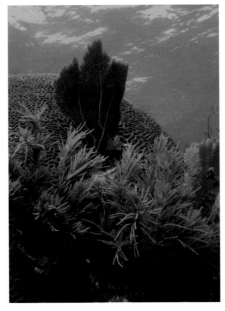

an underwater photographer can find these specific subjects. I mention them to make the important point that you may need to travel to get the images you want.

When researching locations, do some research into the type of diving that can be done, the diving conditions, and what they are like at different times of the year. The location may be home to your subject of choice, but the diving conditions may challenge your diving abilities. I don't know about you, but I am not a Navy SEAL; if I need to travel to photograph a particular subject, I am going to find the easiest diving conditions I can.

**Wrecks.** I included wrecks as one of the six subject categories photographed by underwater photographers, so some discussion of the subject is in order. Wrecks are challenging to photograph because it is difficult to show just how big the wreck is. To rectify this, I try to include a secondary subject (such as another diver) to provide viewers with a reference point that will help them put the size of the wreck in perspective.

Typically, wrecks are photographed in a similar manner to reefs and corals. Starting out using a wide-angle lens to give a panoramic (and usually monochromatic) view of the wreck, then use a lens with a narrower angle of view to photograph the wheelhouse or portholes, companionways or hatches. Finally, use a macro lens to photograph the small coral polyps encrusting the wreck and the marine life inhabiting it. The fish can serve as your primary subject, and the wreck can be cast in the role of secondary subject.

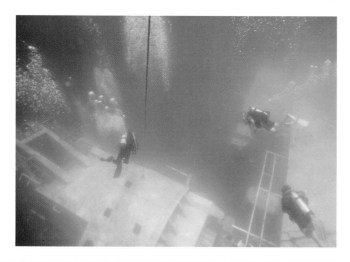

TOP LEFT—A wide and nearly monochromatic view of the wreck. BOTTOM LEFT—Using the standard lens, I created this view of a section of the USS Spiegel Grove. BELOW—I used a macro lens to photograph an early wreck inhabitant: an octopus.

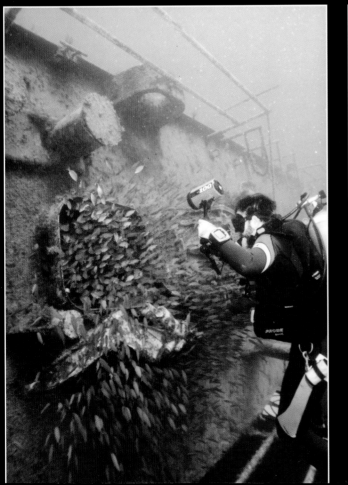

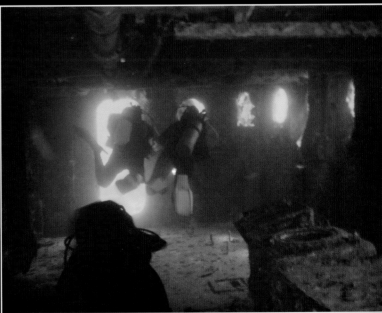

LEFT—A diver on a wreck. ABOVE—Divers inside a wreck. TOP—
Marine life on a wreck.

TOP LEFT—The crow's nest of the USS Duane shown in silhouette. TOP RIGHT—One of the Spiegel Grove's propellers. BOTTOM LEFT—The bow of the wreck of the Benwood. ABOVE—The Wheelhouse of the wreck of the Spiegel Grove.

FACING PAGE—Antiaircraft gun placement recoil springs on the USS Spiegel Grove.

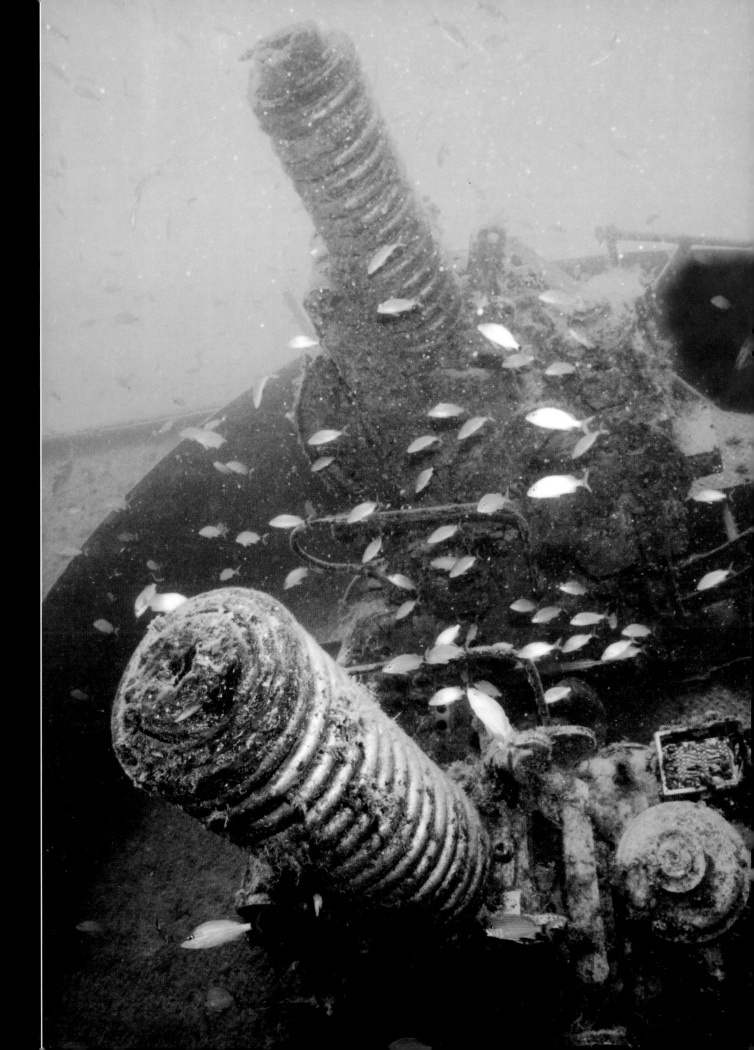

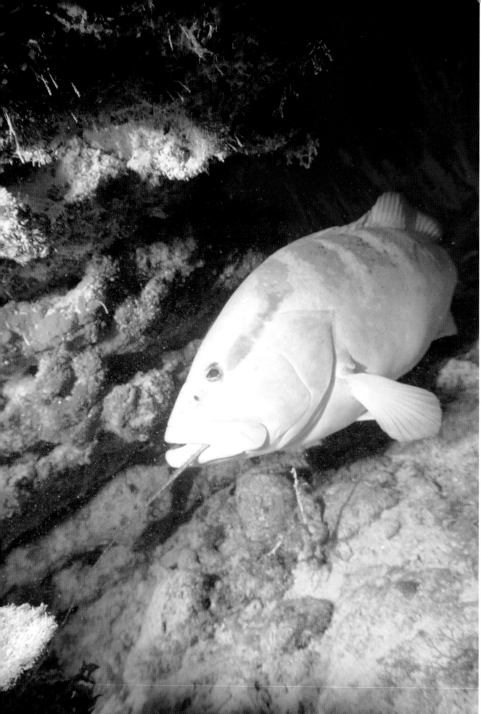

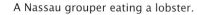
A Nassau grouper eating a lobster.

Photographs of wrecks can yield a wide range of emotional reactions from viewers. To me, a monochromatic photograph of a wide expanse of the ship can evoke a sense of mystery and intrigue. An image of divers crowding a wreck and having fun diving on it makes me smile. Large schools of bait or predator fish on the wreck makes for a dramatic photograph.

When photographing a wreck, you will find that certain areas provide popular opportunities. Shots taken of these areas are referred to as "signature shots." Two such examples are the antiaircraft recoil springs on the USS Spiegel Grove and the crow's nest on the Coast Guard cutter the USS Duane, both in Key Largo. Other popular subjects include the bow, wheelhouse, and propellers. Shooting the subjects outside of the wreck from inside the wreck is another popular option—however, taking photographs from inside the wreck requires additional scuba training. Always keep safety at the forefront of your mind; never photograph in areas where you are not trained to dive.

**Predation.** Predation (one subject eating another) is another subject that some photographers may want to try to photograph. Unfortunately, it is an occurrence that is

First attempt.

Second attempt.

Third attempt—this one is the keeper!

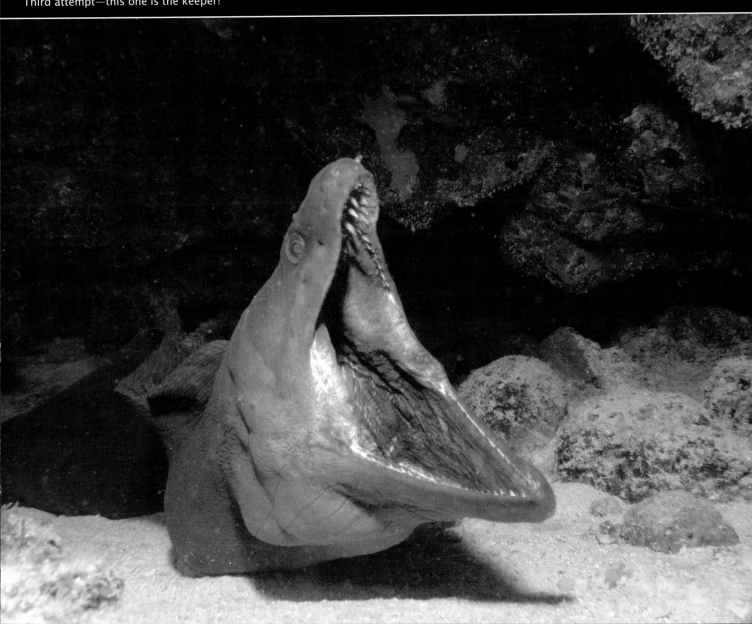

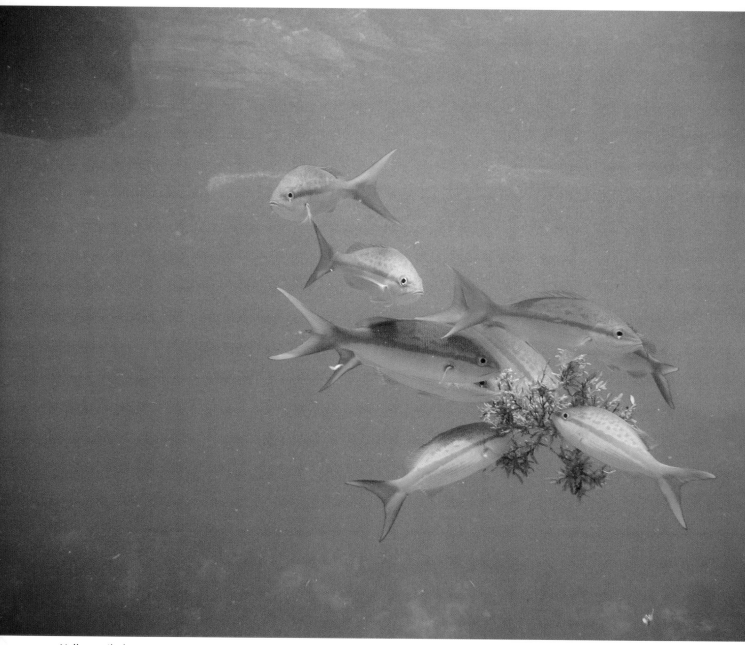

Yellow-tailed snappers preying upon the small shrimp that reside in flotsam.

rare to witness, let alone capture. I've witnessed this behavior on dives when I had my camera, but it happens so quickly that it is difficult to photograph.

**IN CLOSING**

If a subject is worth photographing, it is worth the time it takes to shoot more than one image (for an example, see the photo sequence on the previous page). Doing so will increase the likelihood that you will get at least one shot that is sharply focused, well-exposed, and pleasingly composed. You may be asking, "Well, how many is enough?" My advice is to consider the amount of dive time remaining and your air supply, then shoot until you are confident that you have exactly what you wanted. Rarely do any of us get it right on the first shot.

# 5. CAMERA CARE AND MAINTENANCE

What you can learn in this chapter about caring for your camera—and how to maintain and handle it—should be worth the cost this book! I want to note, however, that the following information should be regarded as general techniques. Whatever guidance is provided in the literature that came with your camera and equipment should take precedence over what is written here because it is specific to your camera and equipment.

Underwater cameras, while robust, are still somewhat delicate instruments. While the body of the camera *may* stand some banging about, the glass in the lens (or the lens port) may not tolerate such an incident. Nor, likely, will the camera's controls. Underwater photographic equipment also does not tolerate the trauma of water entering where it should not be entering (called flooding).

Assuming you don't want to purchase a new camera system each time you go scuba diving, you'll need to learn how to care for and prevent damage to your system—and

Greg S. is shown function-checking his camera before the dive.

how to keep the water on the outside! Sometimes I witness abuse that makes me wonder whether the photographer has a new camera system in mind and is purposely trying to destroy the current one ("Honey, unfortunately I flooded/broke my camera . . . so I guess I'll just have to buy a new one!").

There are four times when you will be caring for your camera: before the dive, during the dive, after the dive, and in the periods between dives. The heart of camera care and maintenance beats around a few actions: cleaning and inspecting, lubricating, assembling and sealing, testing for functionality, testing for leaks, and safeguarding your camera system.

## DO YOUR HOMEWORK

Like scuba diving itself, caring for and maintaining an underwater camera system begins with some academic preparation: reading the literature that came with your camera

John M. assembling the camera and strobe for a dive.

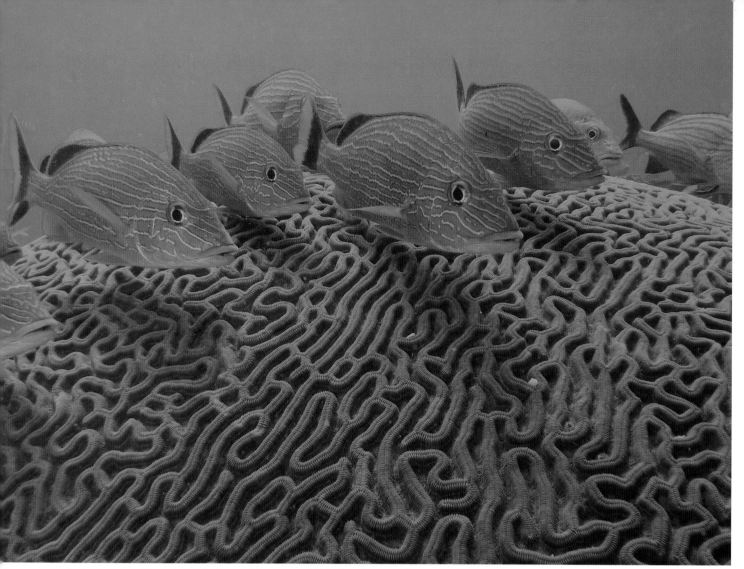

A nice composition when photographing several fish, in this case bluestriped grunts, is to catch them all facing the same way. The trick is to approach slowly, allowing the fish to become comfortable with the photographer's presence.

system is the place to start. These materials will give you a wealth of information.

Unfortunately, some pieces of equipment now come without a manual (or with instructions written in a foreign language—which is fine, I guess, if you are a regular guy who speaks foreign languages). In this case, I urge you to take the time to visit the manufacturer's web site and look for the on-line manual. Once on their web site, you'll normally find this by following a pathway like Products > Support > Documentation. (*Note:* Another helpful source of specific information on how to care for and maintain your camera system may be the retailer who sold it to you.)

It would be nice if we could just take our toys out of their boxes and play with them. None the less, it is important and worthwhile to do our homework—I can even give you a real-life example as to why. A few years ago, I bought a wet-mount auxiliary lens that came in a box with the di-

rections printed in a foreign language (and I am one of those regular guys who does *not* speak or read a foreign language!). Because of my experience, I could figure out how to mount this lens without any need of an owner's manual or a set of instructions. Fortunately, it occurred to me to check the manufacturer's web site for directions on how to care for this lens. There, I discovered that the coating on my new lens could be damaged by letting water dry on its surface. Had I not looked for specific information about caring for my new lens, I might have ruined it the first time out!

## CONSIDER THE DIVE CONDITIONS

Once you've completed your academics, an early consideration in caring for your camera is whether or not the dive site conditions are conducive to underwater photography on the day you are contemplating such a dive. Each time

you dive with your camera you are risking a flood or other damage. Make sure the conditions are worth that risk. There are days where the dive conditions are simply not good for underwater photography.

Is there a strong current on site? If so, can you handle and care for your camera while diving in it? Are the seas rough enough to make you question whether you can get your camera (or yourself, for that matter!) in and out of the water without damaging it? Is the visibility good enough to risk the camera flooding? On some days the visibility is so poor, or the water so turbid, you cannot avoid backscatter. On those days, why risk a flood or other damage to your camera? Are the diving conditions aggressive enough that there is a risk of losing your camera? Are conditions suitable enough that you could deal with both a diver emergency *and* your camera?

Part of caring for your camera is learning to be a good judge of the conditions for underwater photography. If conditions are suspect, it is likely you will have difficulty just taking a picture, much less capturing acceptable images. If that's the case, the risk is not worth the reward.

When I first moved to Key Largo, one of my first dives was to the wreck of the U.S. Coast Guard cutter the Duane. It sits near the Gulf Stream and resides in about 120 feet of seawater. The briefing of the site included mention of a current being present on the wreck. It was an October day and the seas were all of four to six feet in wave height. I was on the swim platform and ready to make my entry when the divemaster asked if he could make a suggestion—and of course I accepted. He advised me not to take my camera on the dive. I asked if this was because of the current, and he confirmed that it was. I agreed and left the camera on the boat. During the descent, I turned to see how my buddy was doing—and the current turned my mask sideways on my face! On the wreck, I was only able to move by using my hands to pull myself along its deck. A good suggestion was made by that divemaster—and I was thankful he offered it!

**CLEANING AND MAINTENANCE**
**Basic Cleaning Technique.** Cleaning the non-camera components of an underwater photography system (the housing, strobe, tray, clamps, and arms) is basically straightforward; you can see whether it is dirty. If it is, soaks of various durations in clean, fresh water are the best

way to proceed. I highly recommend against using any other agents (soaps, detergents, or vinegar, for example) in the water to aid in the cleansing process. During the soak, I manipulate all of the surface controls of the house and strobe to help clean away debris or salt crystals from their shafts. This also confirms that they operate freely and smoothly and are not stuck or binding. I don't use a fire hose to clean or rinse my photo gear. After a soak, I rinse it with gentle water pressure from a shower, water tap, or garden hose.

## A good suggestion was made by that divemaster—and I was thankful he offered it!

Next, I either air dry this gear or I use a soft cloth (or paper towels or a towel) to dry it. (*Note:* When drying your system be careful to not scratch any surfaces you need to see through.) I'm against the idea of using compressed air to dry or help clean a camera housing or strobe. It is my view that doing so could dislocate an O-ring or a seal. Using compressed air could also result in water or debris being blown into the area where the control's shaft meets the O-ring (*i.e.*, not completely blowing that water or debris *out* of that area). If you feel it necessary to use compressed air, then be very careful how you use it.

Throughout the cleaning process—soaking, rinsing, drying—I am also inspecting for any wear or damage. Is something bent, dented, broken, out of place, loose, or missing? I am checking to make sure everything looks just right. I inspect my lens and its ports, front and rear, and clean those as required. If you do not see any dirt, grime, grease, smudges, or dried water droplets on your lens or ports, then you are all set. There is no regular or routine cleaning needed; clean them only as necessary. I use a lens cloth to protect the glass from scratches when I care for my lens or ports. I pat dry my ports and lenses to soak up any moisture rather than using any circular or scrubbing motions with whatever I am using to dry them. I do not use any lens-cleaning agents when cleaning a coated lens.

There are two components to an underwater camera system that keep the water outside, making it watertight. These are O-rings and gaskets. O-rings are more com-

monly used than gaskets; when under pressure (water pressure), they extrude or conform to their adjacent surfaces and form a seal. They are located in an o-ring "groove" on one part of the piece of equipment and mate to a "land" on the second part of this piece of equipment.

Each groove, land, and O-ring must be closely inspected for any damage, wear, or debris each and every time you assemble your camera system. When you are maintaining your scuba gear, it may be acceptable to have a chat with your buddy and "kinda-sorta" be paying attention to what you are doing. When it comes to maintaining or servicing your underwater camera system, however, you should not afford yourself the luxury of good conversation.

There are two types of O-rings and seals, those that are user-serviceable and those that are not serviced by the user. The user-serviceable O-rings, in this context, are those that you access during the normal disassembly of your camera system. You do not need tools to get at these O-rings, which include the main O-ring on the camera's body or housing, the O-ring on the strobe's battery compartment, the O-ring on the camera end of a lens or lens port, and the O-rings on either end of the synchronization cord, which connects to the strobe and camera. These user-serviceable O-rings require more frequent servicing than those not serviced by the user and are typically serviced before the camera is used. (*Note:* In some cases, there are user-accessible O-rings that manufacturers state are not to

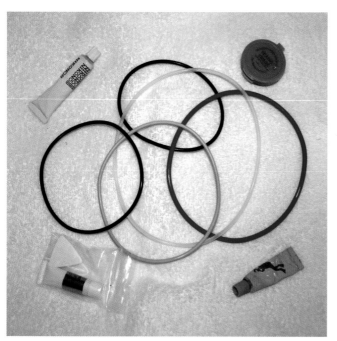
Various O-rings and lubricants.

be removed. This is another reason it is important read the manuals for all of your camera equipment!)

The other O-rings within your underwater camera system, located around the housing/strobe controls and switches, are not user serviceable. Instead, they are typically serviced annually by the manufacturer or a professional camera-service businesses.

Before we lubricate or not lubricate any seal, we want to inspect the area for wear, cracks, nicks, dents, flattening, debris, salt crystals, salt or fresh water, and anything on the seal. Cleaning the seal is best done in a clean, dry place—and you should be clean and dry, as well.

I quite often use paper towels to clean my O-rings and, if needed, fresh water. To clean my O-ring groove, when on land, I use a toothbrush and paper towels. In the old days, we used cotton swabs for cleaning—but we found that they left behind fine, hard-to-see filaments that could lead to floods. On the same note, it is occasionally expeditious to use a t-shirt to wipe the camera system clean or dry. If you do, look to make sure you don't leave any cotton fibers in the wrong place (specifically the O-ring, seal, groove, or land). I carry a few paper towels in my camera bag, which are handy to lay my camera equipment and O-rings on. Because they are white, I can see my parts sitting on them and see whether any debris is near these camera parts. I also carry a clean washcloth in my camera bag.

As you clean, take care to not move any debris into your camera body, its housing, or any other component of your system. Hold or position whatever you are cleaning in such a way that any dirt or debris falls out and away from the innards of your equipment.

During the inspection and cleaning of your O-ring, you should also note that it feels soft and supple with little or no "memory." For example, even if the groove that the O-ring lives in is rectangular, the O-ring should not be rigidly rectangular in shape when removed. If an O-ring feels hard and no longer has any suppleness, or has a rigid memory, that's when you should consider replacing it. (*Note:* The other school of thought on O-ring replacement is that they be replaced once a year. My thinking is this: as long as my O-ring is still soft and supple and has no rigid memory, why fix something that isn't broken?)

**Lubrication.** The lubrication process has nothing to do with the actual sealing of the housing—but it has everything to do with elongating the useful life of the O-rings.

# TOOLS AND TRANSPORT

In my camera bag, I carry extra (and usually small) parts stored in plastic zipper bags. I also pack and segregate my lubricants (also in plastic zipper bags) so that if the tube is damaged, I won't have lubricant contaminating everything else in my bag. Also in plastic zipper bags:

- A toothbrush (for cleaning equipment)
- A pencil with an eraser (used to clean any electrical contacts—such as the strobe's battery contacts—that become corroded or covered with substances that could prevent a circuit from being made)
- Spare O-rings
- Spare batteries
- Extra memory cards

It amazes me that we use all this high-tech camera equipment and yet rely upon simple items like paper towels, tooth brushes, and "zippies" to help care for it all!

I also include any tools needed for my camera system (usually small; never a hammer). A word of caution on tools: if you are not absolutely sure what you are doing with one, then don't use it. There is good reason why there are professional camera repair people. It is hard to beat someone at their own trade! Some other handy tools I've packed in my bag and found a use for are:

- A small set of channel locks
- A set of jeweler's screwdrivers
- A credit card (or guitar pick) as a makeshift O-ring removal tool (take care not to damage the O-ring!)
- Any tools that came with my camera or its accessories (housing, strobe, etc.)

Finally, pack a couple of excuses in your camera bag. A good underwater photographer can always use a couple of excuses in instances when the photograph did not turn out! (A couple of my favorites: "There was a lot of turbidity in the water!" and "The fish moved at the last second!")

On the topic of camera bags, you will indeed want to have some sort of bag or case to transport your photography equipment and accessories. This helps safeguard your camera system and prevent pieces from being lost. One requirement is that the vessel be padded to cushion your gear from external shock and abuse. Another requirement is that it holds the gear snugly and securely. You do not want the components banging into each other. There must also be ample room for whatever you want to keep there (including those excuses for why some of your photographs didn't turn out!).

*This photograph, taken in my living room, shows the various types of bags and cases that are available to hold underwater photographic equipment. Some were made specifically for the purpose; others are makeshift.*

*Types of Lubricant (Or None).* Way back when, in the old days of underwater photography, O-rings were all made from the same compound and were black in color. Then, it was acceptable to use any silicone lubricant that was available.

Later, O-ring makers started using different compounds—and they were also made in other colors (I doubt they were attempting to make a fashion statement here, but, who knows?). Three other colors that I frequently see are red, yellow and blue. These O-rings each demand a specific type of lubrication—and which kind is defined, yes, in the literature that came with your camera system! On this same note, some makers of underwater camera equipment want you to use only their brand of lubricant.

Even more recently, manufacturers began making O-rings and gaskets that do not require any lubrication whatsoever. Would it hurt to still go ahead and lubricate such a seal anyways? I don't know. You must follow the guidance given by the manufacturer. At least one manufacturer is quite adamant about not using any lubricant on that type of their seal. The O-rings I've seen for which no lubrication is recommended are gray.

It just goes to show that you can't rely on past experience. You have to follow the guidance of the manufacturer. Using the wrong lubricant (or any lubricant where none is called for) can result in the malformation of the O-ring, gasket, or seal—and be the cause of a flood.

*Applying the Lubricant.* Once you have a clean camera, lens, and ports—and a clean O-ring, groove, and land—it is time to apply the lubricant, if required. I squeeze a little bit of it onto my the tip of my index finger, then apply it to the O-ring. I spread it all around the diameter and circumference of the ring and take care not to use too much.

This is not an instance in which if a little is good, then more is better. There should be no globs of lubricant remaining on the O-ring; the O-ring should end up looking shiny and wet. Excess O-ring lubrication tends to collect foreign material, which can lead to a flooded camera or strobe. There is a reason why O-ring lube is sold in very small containers and not pint-sized tubs! A tube of O-ring lube will last me a year or longer—and I use my camera more frequently than most.

Photographing reef scenes in the portrait mode is a favored technique. Here the Orange Elephant Ear sponge's color compliments the blue water in the background.

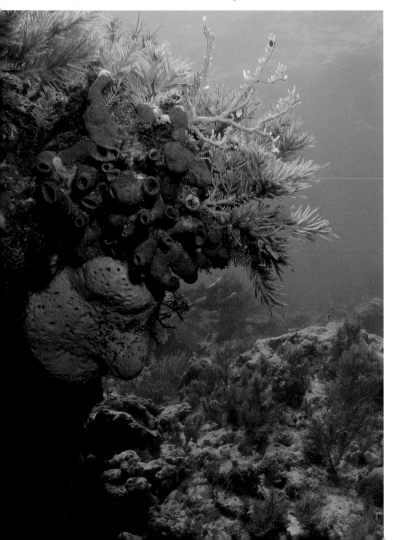

Here is a humorous and true story about how much O-ring lubrication to use. Years ago, I was taking a professional-level photo course and my instructor told me that he asked a top manufacturer's head "guy" about how much O-ring lubrication should be used. The answer was, "Just exactly the right amount!" So there you have it. Straight from an expert, to one of my photo mentors, to me—and now from me to you. Only once have I read in any manufacturer's literature (one from Olympus) exactly how much lubricant they recommended using. It was 5 millimeters—and the O-ring's circumference was approximately 14 inches.

When you are working with these lubricants, take care not to contaminate your other camera parts—especially your lens or lens port. Once you've lubed your O-ring, clean your hands thoroughly so you don't end up with lube some place—or every place—else! I wipe my hands on my dive t-shirt; more well-mannered underwater photographers will use a paper towel.

*Installing the O-Ring.* Once we have our O-ring cleaned, inspected, and (if needed) lubricated with just the exact right amount of lubrication, we are ready to install it. Take care to not stretch it any more than is necessary and make sure that it is properly seated in its groove. Also, when closing your camera's housing, or a component of the camera system, take care to not dislocate it. The O-ring is now installed and the housing (or strobe, or other component) can be closed and sealed.

*Don't Force It.* You should not need an inordinate amount of force to close anything in the assembly process. If you find yourself using force when working on your camera equipment, stop! Having to use excessive force is an indicator that you are probably doing something wrong and can cause damage to your equipment. You don't have to be an Arnold Schwarzenegger to be an underwater photographer! Refer back to your manual to find or consult someone who may be more knowledgeable about what it is you are trying to do. At the very least, stop what you are doing and take a second look at things.

Sealing surfaces are quite often secured by latches, fasteners, or hatches. In most instances, you will know that you have properly secured one of these because you hearing a "click" as you finish it. I call this noise the "magic click." If I don't hear it, I have reason to suspect that I may not have properly assembled (or closed) my piece of

equipment—and therefore may not have sealed it. Listen for those "magic clicks."

## SETTING UP FOR A DIVE

It does not matter in what particular order you do something—first, second, third and fourth—but it helps to have a routine when setting up and readying your camera system. If you do, you are more likely to be thorough and less likely to forget to do something. With repetition and time you will become less tentative about handling and assembling your system.

Don't become complacent. Be attentive to what you are doing and try not to get distracted. Simple but costly mistakes can be made if you lose your focus. More than once I've become distracted and forgotten to put a battery in either my camera or strobe—and on more than one occasion I nearly forgot to reinstall an O-ring. Two other errors I've encountered are the failure to load my camera with film (or its memory card) and not fully securing a synchcord fitting. These are rookie mistakes, to be sure, but they can still be made well after your rookie year!

Once you've got your camera system cleaned, inspected, serviced, sealed, and assembled you should function-check it. Turn on the camera and strobe and take a test shot or two. Ensure that your strobe is firing and in synch with the shutter. Take a good, scrutinizing look at your system and look for signs of trouble. If everything is working and nothing looks wrong, you should be ready to take your camera diving.

To function-test for strobe synchronization, take a photograph of the side of your strobe. Upon review, you should see that the photograph includes the strobe firing.

**Look for a Camera-Friendly Charter.** I do almost all my diving from a boat, so I try to seek out a charter service that is what I call "camera friendly."

Camera-friendly charter companies have a few things in common. They typically have an area on board that is dedicated to cameras and photographers. This area provides a relatively safe place to store cameras and accessories and an area for the photographer to be able to tend to their camera systems. This area is usually clean and sheltered from the elements.

## Simple but costly mistakes can be made if you lose your focus.

They will also have a freshwater camera-rinse container for the exclusive use of the photographers. Once your camera has been in salt water, it is important to keep it wet until you can rinse it with fresh water before drying. A dedicated rinse container is necessary; the other rinse container on the boat may be for mask defogging, and mask defogging agents can cause damage to some lens coatings and/or camera seals.

Another important aspect of camera-friendly boats is that their crews have some basic knowledge about how not to damage cameras when handling them. Diving with this kind of charter service can literally make or break your camera! When they've been helpful, an offer to finance the cost of their favorite beverage is welcomed!

**Be Prepared.** I try to remember to start my photo dive day with fresh batteries in my camera and strobe and a clean or empty memory card. Without fresh batteries and a clean memory card, you can end up midway through your dive and have your camera quit working or find that there is no power for your strobe. This results in a need for you to change batteries or memory cards between dives, and opening up your camera system to do anything while on the water is never the ideal. Here's another good reason to start with a fresh card: if you do suffer a camera flood, you won't lose anything left sitting on your memory card (like the photographs of the whale shark you took on the previous day).

## THE DIVE TRIP

**On the Boat.** I try to keep my camera out of the sun if possible. Larger boats that are camera-friendly usually locate their camera table within a sheltered (from the sun and weather) area of the boat. If there is no such place, I place a towel over my camera to shield it from the sun.

In a diplomatic way, I suggest that you try to keep other curious divers away from your camera system. They are dealing with a lot of heavy gear and often do not have great sea legs. As a result, they can be prone to dropping things and losing their balance. It does not take much to crunch a camera. Some divers do not understand that the camera table on a boat does not serve a dual purpose as a weight-belt building station!

Additionally, other divers don't always realize that water and open cameras (or camera bags) don't mix well. They mean no harm when they approach you and your camera system. They may just want to strike up a conversation. They may ask a question about your camera or underwater photography. Meanwhile, they are inadvertently dripping water all over everything! I prefer to chat with them while they drip dry some place else—not on my camera and/or into its bag.

When I place my camera on a camera table, or otherwise set it down, I place it port-side down. I place my strobe glass-side down. When I do this, I place the camera on something soft and clean, like a small towel.

If I need to work on my camera during the dive charter or trip (to change batteries or memory cards, for instance), I first dry the whole camera as best I can. Next, I dry myself as best I can. I roll up the sleeves on my wet suit, if I am wearing one. I dry my hands, wrists, face, and hair (the "drying the hair" part is easy for me!). I want to do this work in a dry area and keep my friendly—but wet—fellow divers and their natural curiosity away from my camera.

I also want to work very efficiently. If I am changing batteries or film or memory cards, I have this all laid out before opening up the camera system. Everything I need should be at hand. The idea here is to keep your camera system exposed to the elements for the shortest possible amount of time. This is not a moment to take a bathroom break. You don't have to feel rushed or hurried—nor *should* you hurry—but strive to be organized and efficient.

**Before Entering the Water.** Before entering the water, I submerge my camera system into the freshwater camera-rinse container. If it is going to leak or flood, I'd rather have it do so in freshwater than in saltwater—and I'd rather know about it before I am in the water. The "tell" will be a slow steady stream of small air bubbles arising out of any of the camera system's air-tight compartments—specifically

Camera in a camera-rinse tank.

the camera's body or housing and the strobe's battery compartment. Not seeing those bubbles is a good thing!

I do not, however, make it a practice to leave my camera in the rinse container while the boat is in transit. The camera will slosh around in the container and be banged about. Also, there may be other cameras in the container—and cameras do not date each other, fall in love, get married, and have baby cameras (although it would be nice for us if they did!). Rather, they make war with each other—and the battlefield is the camera-rinse container. One camera may lose the war, and I don't want it to be my camera. There is also a risk that the camera-rinse container will tip over and spill its contents. I know of at least one instance in which the whole container went overboard with the cameras in it!

If your camera is either positively or neutrally buoyant, you do not want it floating in a camera-rinse container. This holds true whether the boat is underway or not. Your camera should be either all the way out of the water or all the way under the water. If part of a seal or O-ring is underwater and part of that same seal is above water, there is a flood risk at the water line.

Now, I've dwelled on camera-rinse containers for quite a while here, but with good reason: I have witnessed more floods of cameras—especially digitals—involving camera-rinse containers than floods caused at depth.

**Entering the Water.** Once I've checked my camera for leaks I am ready to enter the water. The best way to enter the water is without your camera. *Sudden Impact* was a good movie, but it's not a good first move for your photo dive. Enter the water, then have your buddy or a member of the boat crew hand you your camera. Once in the water with your camera in hand, keep the camera either all the way out of the water or all the way under the water. Do not sit there bobbing on the surface with your camera also bobbing on the surface.

**The Descent and Dive.** Once you've made your descent (or during your descent), check your camera again for any leaks. Look for telltale air bubbles emanating from the housing or strobe and any water inside the housing. Clear housings are easy, but if your housing is not clear, look at your lens port or viewfinder for signs of a flood.

Once you've descended, check to make sure your camera and strobe are turned on and that you've got your camera and strobe settings where you want them to be. Using

a swishing action, use your hand to remove any small air bubbles that may have accumulated on the surface of your camera lens or port. Check that your strobe is correctly aligned. Fire a test shot—and if you need a quick subject, photograph your dive buddy. (That will boost their ego and get them off to a good start to the dive!) You've fired a test shot above; if you are unable to fire a test shot below, your camera is telling you something is wrong. It's a good idea to abort the dive and find out what.

If your camera and strobe are connected via a synchronization cord and the strobe fires intermittently, or at will, or does not fire at all, that's another sign of a flood. Typically, one of the fittings has flooded—and that is easy to remedy. If you experience such a sign, exit the water and check those fittings for moisture. Many times, just rinsing and drying the affected parts puts you back in operation.

> ## Once I've checked my camera for leaks I am ready to enter the water.

During the dive, take care not to use your camera as a buffer between yourself and the bottom or reef. Unless the water is cold and you are in need of gloves to keep your hands warm, I recommend not wearing them. Some gloveless divers use their camera as a buffer in order to save injury to their hands when trying to keep themselves positioned or off the bottom. Aside from the obvious and tragic harm you can do to what is on the bottom, you just as obviously risk damaging your camera. If I had not seen this done, I would not be writing about it.

LEFT—This underwater photographer has the camera ready for action. RIGHT—This is one means of affixing your camera system to yourself.

Carry your camera in the ready position, rather than affixed to yourself. A negatively buoyant camera will dangle underneath you somewhere, and dangling cameras tend to collide with things—either you or the bottom. A positively buoyant camera system tends to float up and above and behind you where it can get tangled in other pieces of your scuba gear. In either case, affixing the camera to you makes it slower to bring the camera into play when you want to photograph something. Things are dynamic below; you want to be as ready to grab the shot as you can be and not grabbing for your camera.

However, you should *have* a means to affix your camera system to yourself and free up both your hands if you need them. It is nice to have both hands free when using descent lines both when descending and ascending. You also want to be able to respond to any emergency or give a fellow diver an assist, which usually requires the use of two hands. Having a quick way to affix the camera to yourself helps you in these instances. I use QDs (quick disconnects) for

this purpose. The female end is attached to my BCD (buoyancy compensating device) and the male end is attached to my camera system's tray. I locate mine low on my BCD, helping to prevent my camera system from getting tangled up with the rest of my scuba equipment.

**Returning to the Boat.** When you've finished your dive and are back on the surface, move to the back of the boat, and hand your camera system up to your buddy or a crew member. Try to hand it to them in a way that makes it easy for them to take from you and they only need one hand to do so. They will then transfer it to the camera rinse container. If your camera floats at all, once you are out of the water you should remove it from the container.

Do not try to exit the water onto a boat while holding your camera—or, worse, having it affixed to yourself. The camera invariably ends up between your body and the boat's ladder. Crunch time!

**After the Dive.** By the end of your dive day, your camera has been submerged in saltwater, then in a freshwater

camera-rinse container. However, that "fresh" water only started out the day fresh; as the day went on, it became contaminated with saltwater.

Before I remove my camera from that rinse container, I like to work all the surface controls of the camera and strobe that I can, hoping to remove or dilute any salt water around the control shafts, fittings, and seals with that fresh(er) water. I am fortunate to dive from boats that also have freshwater showers, so I can also give my camera a quick rinse under the shower after I remove it from the camera-rinse container.

Then, I find that safe, shady place for my camera system and again set it down on a soft towel. A bath towel is useful as it can be used to help brace or shore up your camera and keep it from moving. If for some reason it is impractical to set the camera system port-side or glass-side down, then I set it right side up.

I stay near my camera to watch over it, then enjoy my boat ride home and hope I've got some keepers!

### WHEN DISASTER STRIKES
If you are confronted with a flood, there is not much you can do. Turn the camera off, then remove the batteries and immediately discard them in a trash receptacle. When battery compartments flood, the water and the battery marry

A diver hands her camera to the divemaster before boarding the boat.

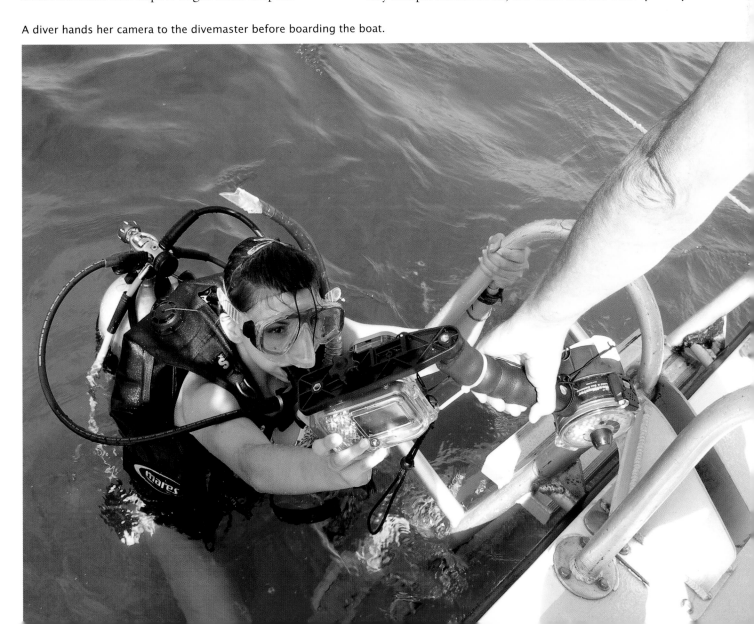

# CONDENSATION

Okay, so "condensation" is not much of a technical term—but it's still important to discuss! Condensation in underwater digital photography is caused by a building up of the temperature inside the camera or its housing, or by a sudden change of temperature. When it occurs, you'll see water vapor or droplets on the inside of the camera lens port (or other see-through parts of either the camera or its housing). Desiccants (often silica packs) are often used to help prevent this, but it can still occur.

One way to make condensation occur is to shoot continuously, which causes heat buildup from the camera's flash and the LCD. The prevention of condensation caused in this way is obvious. The remedy for condensation, in this instance, is to just wait it out. Although I've not seen this often, in some instances the heat buildup and/or condensation can cause your camera to stop functioning. In these cases, the wait for restored function was much longer.

If you develop a problem with your camera while underwater, turn the camera off and turn it back on a couple minutes later. This is akin to re-booting your camera. If this fails, another fix is to remove the battery, wait a few moments, then replace the battery—but do this back on the boat or land, not underwater!

up and give birth to a very nasty-looking, brown, caustic liquid. This should be drained into the trash, taking great care not to spill this liquid all over every thing else around (including the boat deck). If you've ever seen a dive light flood, then you know what I am writing about.

The next step in this first-aid procedure is to remove your film or memory card. If you are using a film camera, set the camera to the rewind position, open the camera case, and pull out the film by its canister. Do not try to rewind the film; doing so will leave residue on your shutter and likely be cause for you to have the shutter later replaced or repaired. You won't be able to get the film developed; it got wet. I have seen—though rarely—images retrieved from memory cards that were removed from flooded digital cameras. If wet, rinse the card with fresh water, gently dry it off, and keep your fingers crossed.

To my knowledge, and as of this writing, there is not much you can do to salvage a digital camera after a flood. As you would with a film camera, you can only rinse with

fresh water any part of the camera that was flooded with salt water, dry it off as best you can, then hope for the best. With a film camera, you can rinse it, dry it, and in many cases have it repaired for less than the cost of replacement. This is not the case with most digital cameras. (*Note:* Dealing with a flooded camera may be one instance where using compressed air to dry the camera after a freshwater rinse may not cause further harm. You don't have a lot to lose at that point.)

Keep in mind that we live in the wonderful day and age of cell-phone connectivity and toll-free numbers to the service departments of camera and underwater photography equipment makers. If you've got a flood and are at a loss as to what to do, try giving them a call. (This has also helped me troubleshoot a malfunctioning camera.)

Strobes can also flood. Most strobe floods that I have witnessed involved the flooding of the battery compartment. Fortunately, most—but not all—modern strobes are constructed so their battery compartment is sealed from the strobe's other components. With these types of strobes, flooded battery compartments are easy to overcome. After removing the batteries, rinse the battery compartment and its cover with fresh water and dry everything off. Check the contacts for corrosion; if there is any, use a pencil eraser to remove it. Then, install fresh batteries and seal the compartment—making sure to double-check its seal and closure. In most cases, the strobe will be operational again.

If you shoot long enough, sooner or later you will have a camera flood. From 1992 to this date, I've been fortunate and had only three floods—two with one camera, and one with another. In all three cases, the flood involved only a few drops of water and I was able to have the cameras repaired. In the case of the first camera, the technician who repaired the camera could not tell me the cause of the flood—but years later I learned it had a reputation for floods of unknown origin. In the second case, the other camera had no electronics and I was able to rinse it with freshwater. I used a hair dryer on low temperature to dry it while working its controls. I still have no idea what caused these floods, but acknowledge it was some sort of user error. Knock on wood—I have been most fortunate in this regard.

Given the likelihood of problems, it is not a bad idea to insure your camera system. To avoid "wasting" your dive

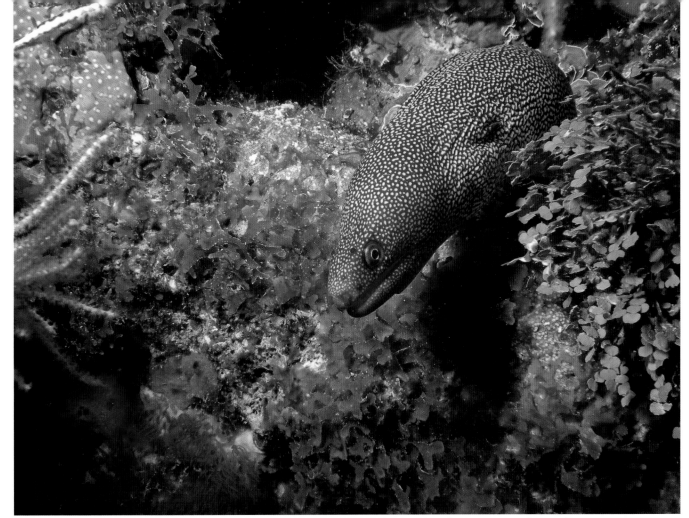

Here a spotted moray eel provides a photo opportunity by moving out from within the recesses in the coral.

trip, you may also want to carry a backup camera—just in case. There are many affordable, compact point-and-shoot models available, and some photographers buy one of these as a backup. Sometimes it may even be possible to rent a camera at your destination.

## STORING YOUR GEAR

Unless you shoot frequently, there will be periods of time when you are not using your camera system on a regular basis. In those cases, you will want to store it effectively.

When storing a camera, I remove its user-serviceable O-rings, clean and lubricate them, then place them in a plastic zipper bag. I also remove the batteries from the camera and the strobe. I put a couple desiccant packs in another plastic zipper bag with my camera body—and it's stored that way. The strobe and lens, with its lens caps in place, are stored the same way.

I periodically check my camera, strobe, and lens for any mold. I also check any electrical contacts I can see for signs of corrosion. I have sometimes found corrosion on syn-

chronization-chord contacts and used electronics cleaner (in a spray can) to successfully remove the corrosion. If you use such a cleaner, make sure it is not harmful to plastics.

Some camera trays, arms, handles, etc., bolt together. I recommend these be disassembled every few months and whenever you are storing your equipment. Galvanic action or corrosion can cause these pieces to freeze together, making it impossible to later dissemble them. When storing, place the hardware in plastic zipper bags.

## A CAVEAT

I feel compelled to end this chapter with a caveat: what is written here has been working for me. Heeding the words in this chapter is no guarantee that you will not have a flood or other maintenance issues with your camera or system. This chapter's content will get you started down the road to preventing floods and damage to your camera—and for handling your camera system safely. Still, it seems like having issues with our camera gear is the nature of the beast! Good luck!

# 6. PRACTICE GOOD TECHNIQUE

When looking at great photograph, the most-often asked question ("What kind of camera was used to take that picture?") is not the best one. The appropriate question to ask is, "How was that picture taken?" This chapter speaks to that second question; it is about technique. You should also find that this chapter is one of the most fun to read.

## IT'S ABOUT TECHNIQUE, NOT EQUIPMENT

You can consistently achieve good results regardless of the kind of camera you use and without becoming a walking encyclopedia of photographic knowledge. Both of the shots to the right are photographic treatments of the same fish species taken on the same day using the same camera and same camera settings and taken by the same photographer. You can see that the shot on the top treats the subject much more fairly (the fish deserves fair treatment) and is more pleasing to view (the viewer deserves a pleasing view of the fish). Your walls deserve to be nicely adorned. You deserve a fonder memory.

Both of the images are technically acceptable insofar as they are both in focus, correctly exposed, and have a subject. However, the image on the top is more nicely composed. This happened because the photographer knew he needed to get closer and understood the principles used to design a good composition—and had the diving skill to make this happen. It did not occur because he had a better camera or more sophisticated strobe system.

If all you want to accomplish is "taking a picture," it won't make any difference what kind of camera you have or use. It won't make any difference how much or little you know about photography or even whether you've read this book. On the other hand, if you want to do more than

The same camera and settings can be used to create images of varying qualities. The difference between these two images is not the equipment; it's the creativity and attention to detail.

just take a picture—like take a *great* picture—it still won't matter whether you are armed with a camera kind that cost $100 or one that cost $10,000. To take a picture, all you need is a camera; to make an image, you need technique—and technique can be taught and learned. You don't have to buy it.

This chapter expands upon techniques that have already been referenced and provides more detail on exactly how a picture was taken—or rather, how an image made.

## UNDERSTANDING YOUR SUBJECT

Let me begin with the subject of fish—and other aquatic animals—and the techniques involved in photographing these subjects in a pleasing way. That should be easy enough, right?

Part of successfully photographing aquatic animals is in knowing something about the creatures you want to photograph (or may see during your dive and want to photograph). Gaining this knowledge should start above water and before the dive. Studying any number of fish identifi-

Fish can behave aggressively to defend their space. Understanding fish behavior can improve your results when photographing it.

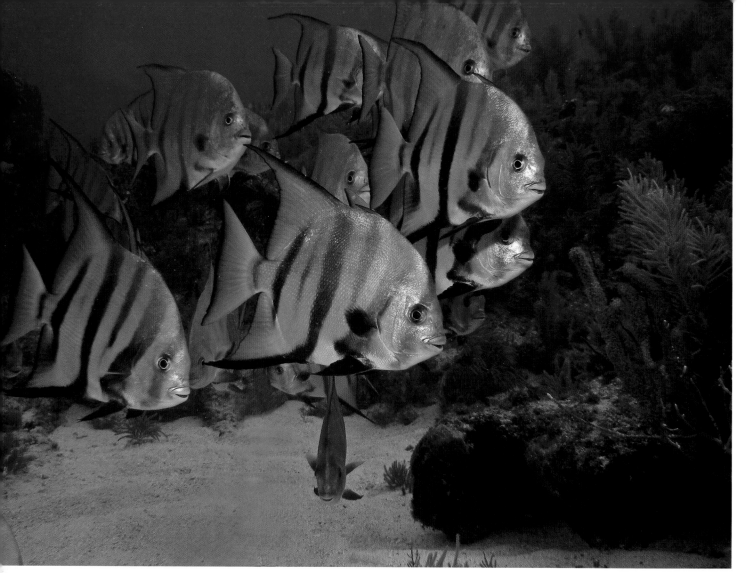

Small school of Atlantic spadefish at Molasses Reef, Key Largo, Florida.

cation books or books on marine life is useful. There are also scuba-level courses you can take on fish identification and their ecosystems. A discussion with local area divers can be another source of information on local fish and their behavior. Additionally, listening to the boat crew's briefing will give you information about which fish you are likely to encounter during your dive and where on the dive site you may find them.

One thing you may learn about the area's fish life is their typical size. This will help you select the best lens to shoot that subject size—or to use the lens you have in the most appropriate manner for that subject. The technology we use in underwater photography boils down to lens choice, exposure settings, and the use of an auxiliary light source. The rest is pure technique.

At this point in my quest, I am at least armed with some knowledge of the fish—and perhaps a bit about their be-

havior and where they are to be found. I am also armed with my camera and prepared to make the focus and exposure settings needed to get the shot.

## TAKE MORE THAN ONE SHOT (BUT NOT TOO MANY)

Once I've grabbed the first shot, I exhale a sigh of relief through my regulator. At least I have one picture of the subject! Is some cases, that first chance may be the only one you get (another reason why having good technique is important). More often, though, you can make subsequent frames and attempt to improve the composition, tweak exposure, or achieve better focus.

I am not suggesting that you fire off a thousand shots, figuring you're bound to get lucky on at least one of them. In my view, there are better—and if not better, certainly more efficient—techniques. To me, the "happy medium" is staying with your subject until you are very confident

that you have captured the image you envisioned. Rarely do underwater photographers get everything absolutely perfect on the first attempt—but if we know what we're doing, we shouldn't need countless images to achieve our objective, either.

An additional reason for a more balanced approach is practical: in film photography you cannot shoot endlessly because you only have 36 frames. Using a digital camera, you have more available frames, but you are still limited by your camera's power supply. For these reasons, covering your bases by shooting enough images makes sense; over-shooting does not.

## MOVE DELICATELY, THINK CAUTIOUSLY

Let's go diving! I am now underwater and in the midst of my photo-dive. The scuba diver inside me is like a computer program running in the background, which enables me to apply my underwater photographic technique to the task at hand: photographing fish.

Part of my technique is to move delicately through the water—not like a bull in a china shop. I am working at "fitting in" down there and want to be accepted by the fish as a non-threatening part of their environment. Most reefs or dive sites are larger than we can cover in one dive, so I don't try. I slow way down, moving slowly around the area of the reef I'm in. Move *very* slowly. If you rocket back and forth and from place to place in search of the Holy Grail, you'll keep all the potential subjects in your area on red alert. Slow down.

I also need to think cautiously. I am going to be working my way closer to aquatic life; some of these creatures may not take kindly to my presence and defend themselves. I want to take a photograph, but I don't want to get bitten in the process! If I'll be settling on the bottom, I'll look at the spot I choose to avoid settling on anything alive or harmful to me—like a scorpion fish or fire coral.

## THE SUBJECT APPEARS

Eventually—hopefully sooner than later!—I will come across a fish I want to photograph. I know it will already have become aware of my presence before I became aware of its presence. At this point, it is still some distance from me and beyond my universe of five feet. It is also below me and not facing my direction. This is becoming a very challenging fish to photograph.

If I photograph the fish at this point, I will be too far away to get color. I will be shooting down at the fish and not get separation. I will be shooting from behind the fish and not capture its eye or eyes. The result will not be much of an image.

Now, if you can't help yourself, and this is the first time you've had the chance to photograph this species, then, by all means go ahead and grab the shot! Use it to determine whether (by reviewing it on your LCD) you need to adjust exposure. Then, settle down and start to envision what type of image you want to capture of this fish species—and which of the following techniques might facilitate your success.

## THE "STALK" TECHNIQUE

The "stalk" technique is a slow, almost painstaking process. It takes time, but when done correctly it enables me to get several shots of the fish.

Stalking is an excellent technique in ideal conditions for underwater photography—clear, calm water, that is void of surge and current—and when your fish is up in the

The stalk technique.

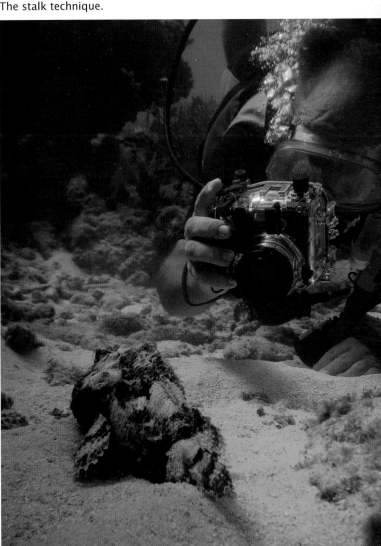

Butterflyfish are abundant in species and on coral reef systems. Here two, spotfin butterflyfish forage on coral polyps.

water column some distance. It's even better when you are able to pull up to your fish and park on the bottom (just be sure you are parking on sand or rubble not coral). It's best for when your fish is already where it wants to be and not in transit from one area on the reef to another.

The stalk is also a lot of fun! With or without a camera it amazes me how close we can get to a fish or marine life with this technique. The stalk technique works well when photographing smaller reef fish, lobster, crab, and moray eels under ledges or amongst the coral.

So, let's return to the scenario presented in the previous section. At this point, I have two things going for me. First, I have yet to frighten the fish because it is still where I first saw it. Second I know that the fish is where it wants to be; it was there before my arrival, stayed there even after

it became aware of my presence, and will likely stay there if I simply pass it by. But I do not want to pass it by; I want to make an image of it.

**Take Your Time.** Patience is a big part of this game. I calm myself down and slow down everything I am doing. I check to make sure my buddy appears to be okay, since it may be some time now before I check again. I consider my air, depth, and bottom time, as well as where I am from a navigational view. If the excitement of seeing this fish and the opportunity to photograph it has caused me to increase my breathing rate or upset my buoyancy, I slow my breathing rate down (remember to breathe!) and regain control over my buoyancy.

This all gets easier to do with more experience diving and doing underwater photography. It's okay to get ex-

cited when you see photogenic subjects—I still get very excited, and I hope I always will. Just remember that until you calm down, that excitement will probably have a negative impact on the outcome of your images.

**Descend to Its Level and Circle Around.** The next part of my technique is to descend to at least the same level or depth (within safe recreational diving limits) of the fish. This allows me to shoot across at the fish and not down at the fish. At this point, I have not closed the distance between myself and my subject. The next step I take—or rather, the next fin kick I make is to move around so I am no longer behind the fish. I want to be in a position to capture the fish's eye or eyes rather than staying behind the fish and capturing its butt! Again: I strive not to disturb the fish. I want it to accept my presence as non-predatory.

**Check Your Settings.** As I'm getting into position, I check my camera to make sure I have it set correctly to photograph this fish and that my strobe is properly positioned. If I am using my film camera, I make sure that my film is advanced and that my shutter release is in the unlocked position. If I am shooting digital, I ensure that my camera is awake and ready to shoot. I am multitasking, but I don't need to be in a hurry. I am not in a gunfight and it is not high noon at the OK Corral.

**Closing the Distance.** The fish is where it wants to be and if I do these two things correctly (descend to its level and move around from behind it) the fish should stay put, content in its position. I can now start closing the distance and bring us both into my universe. My camera is ready, I am ready, and I am hopeful that my approach does not change that fish's mind about being where it is as I close the distance between us.

As I move closer, the scuba diver in me is also taking care not to contact the coral, ensuring that my gauges and other scuba equipment items are secured and streamlined, and watching for anything harmful to me in the area that I might inadvertently make contact with.

**Begin Composing Your Image.** My camera is up as I am closing this distance, and I am beginning to visualize my composition. Visualization is an important part of your technique; you should have the type of photograph you want to take in your mind before you take the shot.

Visualization can start at home ("I'd love to go to Key Largo and take a cool shot of a green moray eel coming at me."), but at the very least it should have been made be-

fore you finish your approach. The point to visualization is to give you an idea ahead of time of what kind of photographic image you'd like to make. If your visualization does not materialize, you can then adjust, as an equally pleasing view may appear before your eyes. It helps, though, to at least have some idea of the outcome of your photograph before you take it. (It also helps later when you review your photographs and are determining which ones to keep.) In my camera bag, I have a list of shots I'd like to capture. When I plan a vacation, I prepare by studying what subjects will present themselves and visualize capturing those in a specific way.

Returning to the fish at hand, I want to move in close enough that the fish fills a pleasing percentage of my frame and position myself so I can capture the fish's eye or eyes. Once this is accomplished, I can finish my composition and take the picture.

**Do a Safety/Buddy Check.** Once you have finished your treatment of your subject, it is time to check back in to see how your buddy is doing. Also, check your air, depth, and time—and, again, consider where you are from a navigational view. If you've made any changes to your camera settings, strobe position, or power setting from your start point, change those back again.

### THE "DRIVE-BY" TECHNIQUE

Another fish-capturing technique is what I call the "drive by." In comparison, stalking is kind of like the "drive-up." The drive-by technique works well when photographing turtles swimming, rays of all species, fellow divers, and individual or schools of fish, such as permit, jacks, barracuda, sharks—or anything moving in the open water.

> My camera is up as I am closing this distance, and I am beginning to visualize my composition.

The scenario here begins in exactly the same way: I see the fish from a distance. Initially, I am above it and behind it, so I proceed toward it slowly, keeping my nerves and excitement under control. I check on my buddy, then descend to the same level (or lower than) where my fish subject is.

**Take a Parallel Course.** This fish is still beyond my universe but instead of moving toward the fish, with the drive-by method, I take a parallel course and close my distance as I swim toward the fish. As with the stalking technique, this is done very slowly. As I'm doing this, I check my camera settings and strobe while visualizing how I want this image composed. I also look around for any contrasting colors and think about how I might separate my subject from the foreground or background. I consider what else (other than my subject) I want in my frame and what I do not want to include. I also know I want that fish's eyes in my image, so I need to get around to at least its side—or perhaps its front. I am not going to be pausing or parking in this instance; rather, I will be shooting while on the move.

**Approach Slowly.** I inch in slowly, closing the distance. With some skill in buoyancy control and some luck, the fish and I will soon be in the same universe. Once I am close enough (the fish fills a pleasing percentage of the frame—usually at about a two-foot distance from the camera, as discussed on page 46) I take my first shot. If all goes well and the fish is still offering me the opportunity, I will move around in a slow and small circle, repeat the process, and attempt a second shot. I repeat this technique until I

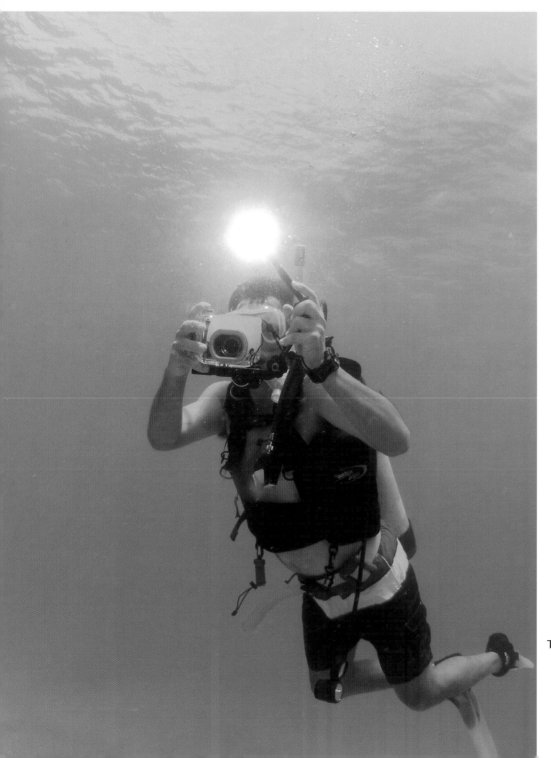

The drive-by technique.

am highly confident that I was successful in capturing the image I visualized—or until the fish moves on.

**In Surge, Current, and Drift Diving.** The drive-by technique works well in instances where, for whatever reason, you cannot park. It also works well when shooting in dynamic water conditions, like surge and current.

When you are photographing in surge, you are not the only one being affected by the back-and-forth movement of the water column—the fish is also being moved by the surge. The trick is to work with the surge so that you and the fish are both being surged in the same direction at the same time. You and the fish are in harmony with the surge.

While I am on the topic of water movement, I should discuss currents. Currents are not necessarily your enemy in underwater photography. Unless we are drift diving, we typically head into the current. When currents are present, fish typically are facing into the current, too—and in a place that shelters them from its force. This means that the fish (and their eyes) are facing away from us to begin with, so we need to fin ahead of the subject and then turn back. You will want to fin further ahead than you think; when you turn back around to compose and shoot, the current will close the distance between you and your subject.

When you are drift diving, your drive-by technique will be powered by the current instead of your fins. You want to be looking out as far into the visibility as you can for subjects so you have time to compose before the current carries you by them. A cautionary note: when drift diving with groups, take care not to get separated from the group by pausing too long with one subject. If you stop to make a photographic "study" of your subject, the next time you look up you may find yourself all alone.

**Fish On the Move.** The drive-by technique also works when the fish is on the move. In some cases—actually in quite a few cases—the subjects will actually drive-by you! A number of years ago, I was photographing fish along a coral ridgeline and looked up and was nearly run over by an eagle ray "flying" over that ridge! In such cases, it is a good thing (this is all about technique, after all) to have your camera set and ready to grab the shot.

## THE "HEAD 'EM OFF AT THE PASS" TECHNIQUE

The next technique I use in fish photography is what I call the "head 'em off at the pass" technique. It's named for those scenes in the old Western movies where the good

Butterflyfish often pair up—as in this case, where two four-eyed butterflyfish are mated. The idea is to make the photograph capturing both fish before they split apart, as they oftentimes do when they feel threatened.

guys would "get" the bad guys by predicting their course, choosing an optimal spot out ahead of them, then wait until just the right moment to shoot.

**Locating the Pass.** Heading your fish off at the pass works more often if you know where the pass is! This can be predicted by observing where the fish came from and looking for an area (the pass) similar to that and which is nearby. Or, you can simply look at the direction your fish is heading and take a guess as to where it may end up. Fortunately for us, reef fish do not travel great distances and seem to be content moving about portions of a reef structure rather than moving to another reef altogether—so the pass normally won't be too far away.

Schooling fish, like blue tangs and midnight parrotfish, often pounce upon a section of coral for a few moments to feed. Then, when finished, they move on to repeat the process on another section of coral. Once you see the direction they are headed, it is not that difficult to find their

next stop (the "pass") and be there waiting. Even if you guess incorrectly, you can revert to the drive-by technique.

**Circling Around.** Once the location of the pass is ascertained, the technique is to circle around—sometimes actually increasing your distance from the fish—and then beating them ("heading 'em off") to their destination (the "pass"). Using this technique, I am already on the scene and the fish will be joining me, sharing this space with me. This means the fish is headed toward me and its eyes are up front.

While putting myself into position, the scuba diver in me checked on my buddy. The photographer in me visualized how I wanted to compose my image. Hopefully, I will get more than one opportunity and be able to make more than one shot. Upon its arrival at the pass, the fish might decide that it wants to stay in this place for a period of time. Hopefully, the pass is also a pretty place and I will be able to include it, or parts of it, in my composition.

**Avoid Spooking the Fish.** As visitors to the undersea world, if we are not grossly obnoxious in our movements,

Trumpetfish seem to believe they are invisible at times; here, one glides with stealth among the corals. This can make them comparatively easy to photograph.

This coral crab only grows to about seven inches, so you need to get close to fill a pleasing percentage of the frame.

body language, and the noises we make—which can be heard or felt (fin turbulence)—it is amazing how well fish will tolerate our presence.

Take a minute and pretend that you are the fish. You are aware of this underwater photographer's presence. Are you more comfortable with him getting closer to you if he approaches from behind you or in front of you? What actions will make you uncomfortable? Are you in harmony with the surge, while the approaching photographer seems to be doing the opposite? If your fins are tucked in to make you streamlined, you might be wondering why this creature looks like a four-armed octopus! What actions give you cause for alarm? What things can you tolerate?

Some years ago, I was talking to a friend who is very active in spear fishing. He told me that if he looked a fish in the eye, it often seemed to spook it and he would not get his shot. As an experiment, I tried the same thing (with my camera, not a spear gun) and had similar results. Now, when I am photographing any aquatic or marine life with eyes, I try to avoid making eye contact; it seems to make the fish uncomfortable.

Instead, I try to give the fish the impression that I really am not interested in it. My belief is that if I demonstrate any overt interest, the fish is likely to interpret it as predatory—which will, naturally, make the fish uncomfortable. Eye contact or not, it is my belief that when a fish becomes aware of my presence it instinctively determines whether I am its predator, and its first reaction is to avoid predation. This may cause the fish to relocate someplace safer—and certainly away from me.

If we want to photograph fish, nothing in our diving or photographic technique should cause the fish to interpret us as predators. When I have witnessed predation, there is normally a sudden, lightning-fast movement on the part of the predator. This is why our technique, both in diving and photography, needs to be void of any rapid movements as we approach marine life.

## THE "SIT AND WAIT" TECHNIQUE

Another technique is what I call the "sit and wait" technique. This technique calls for great patience. Essentially, you descend, check your buddy, check your camera, and then wait for anything that swims up to you and into your universe. After you've sat and waited for a while, the fish in the neighborhood will have become relatively comfort-able with your presence; you've shown no interest, so you're not perceived as a threat. I've seen fish approach underwater photographers using the "sit and wait" technique and wondered whether they did so out of curiosity. Of course, the more likely reason for this is that the photographer just happened to be on the path from point A to point B.

To be honest, I pirated this technique some years ago from an elderly couple who were not engaged in underwater photography but simply scuba diving. They did not care much for a lot of distance-covering to see the various sites. It was their preference to descend, look for nearby fish activity, and fin to it. Upon arriving, they just parked themselves in the sand or rubble and waited, watching the fish life and the nearby coral around them. Of course, their arrival disturbed the scene, but they told me that shortly after their arrival the fish would resume their activities.

To me, that didn't seem like a bad way to scuba dive. After all, scuba diving is more of a vertical thing (descend and ascend) than a horizontal thing (descend and swim great distances). Scuba diving is all about seeing sights. They said they witnessed many wonderful sights diving like this, so I knew it would be a good way to capture some nice images.

**Slowing Down Makes You More Observant.** Here is an exercise for you—one that I teach in my open-water diving course and in my underwater photography course. Next time you are outdoors, take a short run—twenty or thirty feet will work. When you stop, recount to yourself all the things you saw while running. Then, turn around and walk slowly back to your starting point. Again, recount all

the things you saw during your walk. That number will be greater. Finally, put yourself in the middle of this distance and just look around. Recount how many things you saw. That number will be even greater. The lesson learned from this exercise applies very nicely to underwater photography—and especially to this technique.

**Where to Sit.** Where you choose to sit and wait is a key to success in using this technique. Any fisherman will tell you that fish gravitate toward structures. For example, if you are diving at a wreck site and there is nothing but sand surrounding the wreck, where do you think you are going to see more fish? Obviously, at the wreck, as its structure affords more shelter than the underwater version of the Sahara desert. Waiting near a known fish-cleaning station is another a good choice when using this technique.

The sit-and-wait technique is frequently used during "critter feeds," such as during shark feeds. It is also useful when photographing very small fish or critters that are timid. It requires patience, but it's easier than the stalk or the drive-by techniques because it requires much less physical effort.

### THE "BE READY" TECHNIQUE
The fifth technique I use is what I call the "be ready" technique. This technique is also easy. It takes two things: having your camera set up and ready to shoot, and constant observation for whatever may appear in the water column with you, near you, or even heading toward you. When using this technique, you are simply being as attentive to the underwater realm as you are when you are scuba diving and not engaged in underwater photography.

**A Good Starting Point.** My photo dives start off using this technique; when I am not using another technique, it's also what I revert back to. In that sense, I always main-

Dan M. is parked, waiting for the right moment. This technique looks very much like the "head 'em off at the pass" technique; in both cases, the photographer is positioned and static when the subject arrives on the scene.

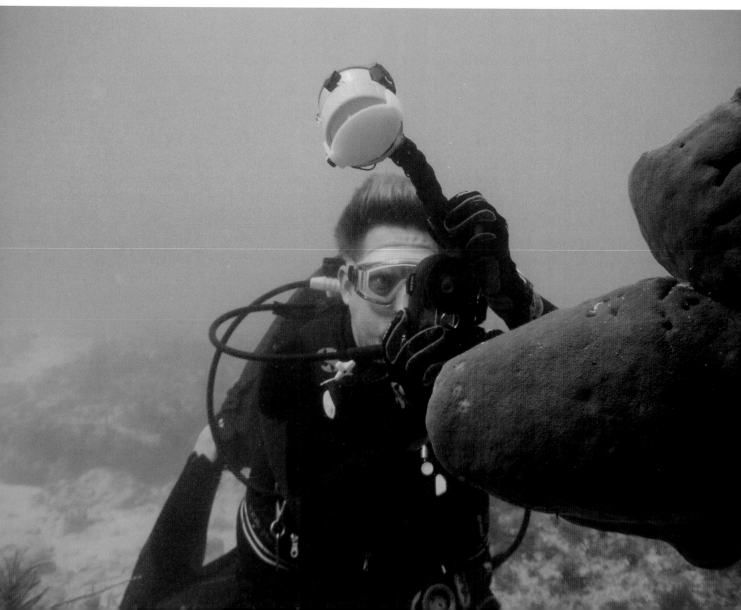

tain some degree of the be-ready technique during my photography dives.

**Always Prepared, Always Observing.** Photographing with the be-ready technique is analogous to driving a car. I may be in one gear, but I am ready to shift into another gear. I may be stepping on the gas, but I am ready to step on the brake. I may be in one lane, but I am ready to change lanes. I am observant and paying attention to what is going on around me and I am ready to react to a change in circumstance and situation.

I've captured many good images simply because I was ready at the moment in time when the event occurred. I was ready because I could imagine what events were possible. I did my study, I talked to the local divers, and I listened to the boat crew's briefing about the marine life on the dive site.

The be-ready technique allows you to be simultaneously engaged in one technique, such as the stalk or the drive-by, but with your eye not only on the current subject but also on what may be coming your way.

I am sure that any scuba diver who is carrying any camera uses the be-ready technique to some degree, whether conscious of it or not. That said, I have witnessed underwater photographers who were not ready. And is one reason why I mention this as a technique. Another reason is to that I want to encourage you to take it another fin-kick forward.

**Don't Become Too Fixated.** I do not want to get so caught up with what is currently happening that I become completely oblivious to everything else around me—to be so caught up in stalking a French grunt, for example, that I miss the opportunity to photograph a green sea turtle that comes into my universe.

Years ago, in Maui, I dove with a dive buddy who loved the small creatures that inhabit the reef. She would (figuratively) bury the faceplate of her mask in the coral, observing these small creatures. One day, while diving together at Molokini Crater, a manta ray glided over the top of us. While I saw it, she was so totally engrossed in finding her small creatures that I knew she missed seeing the ray. After the dive I asked her about it and she remarked, "Oh, I remember that—I thought the sun went behind a cloud." The point is that you should be careful about fully engrossing yourself with whatever is on your plate at the moment.

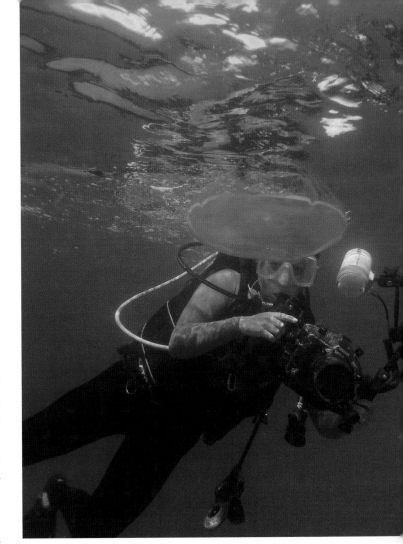

Mary M. uses the be-ready technique, diving with her camera up and in her hands and her strobe aim pre-positioned.

Normally, there are just a few moments at a time when I focus my attention completely on one thing (when I'm not ready for something else) and that's when I'm actually working the shutter release. The only other time I allow myself to become a bit oblivious to the opportunities around me is when I am photographing a subject that is more compelling than anything else that is likely to show up. To continue the above example, if I was photographing a green sea turtle I'd probably be oblivious to the less-compelling French grunt.

## SOME COMMON TECHNIQUES TO AVOID

The five techniques we've just reviewed (or a combination of these) will enable you to capture most fish and marine life in most situations and in most diveable environments. They will enable you to take advantage of the opportunities presented under a variety of circumstances and create an acceptable image. By now you are well on your way in

transitioning from being a picture taker to becoming an image maker.

There are three other techniques used for fish photography, however, that are—to say the least—"less successful." Although they are popular and easy to master, the result is, at best, that a picture was taken. Let's look at these techniques so we'll know what *not* to do.

**The "Barge Right In" Technique.** The first of these techniques, what I call the "barge right in" technique, is very commonly employed and attempted. Here, the underwater photographer sees the fish and simply moves straight on in at it—a one-person Calvary charge! The volume of the photographer's excitement is rivaled only by his lack of patience. The barge-right-in photographer typically begins photographing the fish before they are in the same universe—and usually neglects checking his buddy, his camera, or anything else for that matter.

What happens, as you might expect, is that the fish is spooked and leaves. The fish models for the photographer by showing its tail or butt. At this point, the photographer usually gives up (he can no longer even see the fish, after all)—but only with this particular fish! He will then repeat this easy-to-master technique and the madness of it will live on, yielding the same disappointing results and outcome every time. Later, the fish will be described as "uncooperative"—or the photographer will complain that the fish "moved at the last moment." Fish and marine life are neither cooperative nor uncooperative; they are just there. And, in this instance, the fish moved at the *first* not the *last* moment!

# The fish models for the photographer by showing its tail or butt.

When imagery of that fish is viewed, the photographer's description may sound kind of like this, "See? Look there—just above the center! There's that fish! Look closer—you can see it! There's its tail! That fish was moving so fast I was lucky to get even this shot of it! Whadda ya think?" My straight-faced reply to that question varies, but usually sounds something like, "I think that is one of the best captures of how fast a fish can swim that I have

seen for some time,'" or, "That is the nicest—I'd even suggest *classic*—shot of a fish butt I've ever seen taken at this dive site. What kind of camera did you use to take that picture?"

Whether or not the photographer takes my tongue-in-cheek reply seriously (it's all great fun), I try to suggest a technique that would work better and regardless of what kind of camera is used. One suggestion would be to use a bit of patience.

**The "Chase" Technique.** If the underwater photographer immediately abandons the barge-right-in technique after the fish has bolted, he will often switch to another technique: the chase. This technique is at least equal in popularity to the barge-right-in approach—and it's easy to understand why: it can be used as a backup or follow-up.

The chase sounds thrilling. After all many action movies have car chase scenes in them and they are extremely exciting. To tell you the truth, it does look fun. I'm sure it's exciting for the underwater photographer (and I suppose it may be exciting for the fish, too, but probably for a totally different reason!).

Unfortunately, the chase technique yields similar results to the barge-right-in technique—and it can involve some peril, or at least a breach in safe diving practices. The photographer may end up chasing the fish into deeper water than planned, for a long enough distance to become lost, or for a long enough duration to overstay the allotted bottom time. He may chase the fish to the point of becoming overexerted. Chasing a fish can also cause buddy separation. Certainly, it has a negative impact on the fish.

Underwater photographers who use the chase technique usually don't have a lot to say when showing you the resulting images. One that comes to mind is, "See? There's that fish I was telling you about—over there in the upper center of my picture. I need a different/better/more powerful strobe, though, because I didn't get much color." Given my "bad" sense of humor, my reply could go something like, "I see it now! I thought you wanted the photograph to be monochromatic," or, "I like how you thought outside of the box and creatively included so very much of the subject's surroundings in your composition."

**The "Gunfighter" Technique.** The third technique in this series is what I call the gunfighter technique. The gunfighter shoots everything—but only once. Then he moves on to another target. The gunfighter is confident that he

It helped to "be ready" when this school of horse-eyed jacks rushed by and overhead.

is a good shot, so he can shoot from the hip—even one-handed—from any and all angles and at any distances and at any sized target. The gunfighter is quick.

The gunfighter technique is a lot of fun—I don't blame anyone for using it. After all, the gunfighter may not be "in town" very long and wants to get as many shots fired as possible. Plus, the gunfighter gets to use his camera an awful lot during the dive! The gunfighter (who wears a white hat, by the way) is typically in a hurry and moves quickly through the water, using rapid movements to raise his camera—and sending out danger signals to the aquatic life, near and far. (At least the fish don't shoot back . . .)

I am confident by now you can forecast the results of using this technique. The gunfighter comes up with *many* photographs to show and to talk about. Be prepared to look at a lot of them and to hear all about his glorious gunfight with each capture. (My first comment is, "Do you mind if I get a beer before we look at these?")

**Don't Do It.** If you find yourself tempted to engage in any of these last three techniques, popular as they may be, just stop. By virtue of the fact that you are reading this book, you've moved beyond that. The people using these three techniques are scuba divers who happen to be carrying a camera; they are not underwater photographers. The best you will come away with is a picture—a picture that, given what you now know, you will not even end up wanting to save. In the meantime, you'll have wasted energy, bottom time, air, and camera resources. (Granted all three techniques are fun. When combined, I liken it to "Underwater Photographers Gone Wild!")

Yet, there is an even more significant downside to using these techniques: they disturb the fish and marine life. The use of these techniques interrupts the marine life while it is trying to "make its living." When we disturb the marine life, we cause these creatures to expend energy they may need to escape a *real* predator. At the very least, implementing these bad photographic techniques temporarily disrupts the normal behavior of the marine life in that community.

We should strive to make our images without disturbing the marine life. Using good photographic technique will reward us with better, more natural portraits of our subjects—and the peace of mind that comes from knowing our subjects will not suffer undue consequences.

## You'll need to decide for yourself whether or not this is acceptable.

**Potentially Harmful Techniques.** In the past there were other techniques used to photograph fish and other aquatic life. Capturing and/or handling aquatic life was one of these techniques, as was enticing subjects into the photographic universe using bait or foodstuff. The capture or handling of aquatic life has gone by the wayside, as it was deemed harmful to the marine life and came with risk of diver injury. Feeding has, for the most part, also gone by the wayside. The only instance of this that I am presently aware of is shark feeding done for the purposes of diver interaction or photography. Whether or not this should be done is a matter of debate in the diving community. Personally, I am of two minds on this matter; if you're interested in photographing sharks, you'll need to decide for yourself whether or not this is acceptable.

### REMOTE CAMERAS

I will briefly touch on one other technique used (although not often, if ever, by the "regular guy"): photography with a remote camera. This technique is very similar to the sit-and-wait technique, except the photographer is some distance away from the camera and remotely actuates the shutter at the decisive moment. Although I have not attempted it myself, it is an interesting technique. While it is

my impression that this strategy is only rarely employed, I can imagine situations where it would be useful. Garden eels and jawfish, for example, are notoriously diver-skittish creatures—or perhaps my aforementioned dive buddy in Maui could use this technique so she can be on the watch for manta rays!

### WHEN PHOTOGRAPHING CREATURES, SOMETIMES NOTHING WORKS

There are some situations when none of these techniques will work. Your subject may be so far away as to make it impractical to attempt closing the distance. It might stay in one place but be swimming about so rapidly that it would be pure luck for you to get a focused capture of it. It may be that there is no way for you to shoot from any other position than down at the subject. The subject may have its eyes so obscured by the surroundings that you cannot take a photograph that includes either of them. The subject may come and go so fast that even the be-ready technique is not up to the task.

Part of the technique in underwater photography is predicting ahead of time the possibilities or odds of accomplishing your goal. If they seem low, move on to something more promising. An element of good technique is realizing when what you *want* to happen is *not going* to happen. We are underwater for short periods of time and all of our resources during that time are finite. If you conserve them and use them well, your underwater photography will improve for having done so.

### PHOTOGRAPHING THE REEF

Now that we've covered techniques used to photograph fish and marine life, let's move on to techniques for photographing another subject: the coral reef itself. This is an even easier subject to capture—after all, it's not going to swim away from you!

**An Amazing (and Often Overlooked) Subject.** I compare the majesty of the reef to the majesty of the Rocky Mountains. Reef scenics (reef-scapes, as I sometimes call them) and images of coral are, in my opinion, among the most glorious types of underwater imagery—and among the most artful. They are a magnificent subject choice for underwater photography.

Coral and the reef are rich with colors. They also have unique forms, textures, and shapes that are theirs alone.

A coral reef.

These subjects also offer a range of sizes and constructs, making them suitable for any type of lens (from wide-angle to macro). There many species to choose from—and you can photograph whole segments of reef, or a part of the reef, or a particular species of coral, or clusters of coral polyps. Corals are also among the easiest subjects that underwater photographers can photograph. If any subject is cooperative, the corals are.

Despite all these positive attributes, they are among the most overlooked subjects, frequently regarded as secondary subjects to whatever else may be the primary subject in the image. Corals are included in most underwater photographs, but as either the foreground or background (or parts of both). Corals seem to have been given the role of the supporting actor.

The only difficult thing about photographing the reef is capturing the viewers' appreciation of the subject photographed. I believe that is because viewers are simply accustomed to seeing a fish, diver, or some other creature in the image. If that other element is absent, the reef scenic may be viewed as disappointing. (It's sort of like that old fast-food commercial where the woman (the viewer) looks at her meal (the image) asks, "Where's the beef?")

In my opinion, though, the reef is well worthy of capture. It is one of the most wondrous sights we see. It adds richness to the experience of scuba diving in a tropical location. It in itself is a worthy subject to photograph, to share, and to be remembered—and, to our good fortune, it is not all that difficult to photograph.

**Photographic Technique.** When photographing coral you can freely use the barge-right-in technique; you do not need to stalk the coral. In certain sea conditions—those with current and surge—you may need to use the drive-by technique. Coral is often adjacent to sand or a rubble bottom, so you may even be able to park yourself and shoot. This makes it easy to shift and hold your position when composing (just be sure that you do not stir up the bottom when parking).

When photographing coral, I can virtually eliminate two—if not all three—of the dynamics of photographing underwater. The coral is not moving and, as just mentioned, I may be able to stop moving, too. At times, the water is also still and void of surge or current. When this is the case, photographing coral is a great way to spend at least part of your dive. (And if you've got the be-ready technique in the back of your mind, who knows what else might show up as you are engaging yourself with making images of reef scenes?)

Another advantage of photographing the reef is the your distance is fixed, so focus is much less of an issue than when trying to photograph a moving subject. After one or two shots you should be satisfied with your exposure. From there, it's all about composition.

**Concentrate on Composition.** When photographing corals, you have the luxury of time; your subject is not going anywhere. That makes it much easier to be patient and concentrate on your composition.

Begin by taking a photograph of whatever it was on the reef that first attracted you. Something about it looked pretty enough to catch your eye, so that's a good starting point. If it looks pretty to you, it will probably look pretty to someone else, too! It's a simple lesson, but it's true. I view all coral as being potential photographic subjects, but what I am really looking for is some part of it that stands out. When I find that, I have my subject. If you are paying attention, your eyes will naturally find this.

Once you have your first shot "in the can," take a closer look at what you are photographing. Think about things like light. Where is the sun? Am I shooting into the sun or is it over my shoulder? Do the colors of and in the corals look more vibrant if I look at it from another angle?

Look for colors that complement one another or offer contrast. One of my favorite reef scenes is a photograph of a common sea fan (purple) that is near enough to an orange-eared elephant sponge that both are included in the composition. The negative space in this image is the blue water column. If you've looked at and studied the scene, you may find that you can toss in some yellow and red-wine colored sponges—and you've got a very nice image in the making!

Unless you are shooting in currents or strong surge, you have total control over your universe when you shoot reef scenes. What a luxury.

**Further Guidelines.** The following are some additional tips you can use to enhance your results when photographing reefs.

*Find a Great Subject.* Unless you are shooting macro images, look for a reef that has good profile. Low-profile patch reefs are less satisfactory than reefs high in profile

A photograph that includes Snell's window in its composition.

and somewhat mountainous. Take care in choosing your location.

*Pick a Good Angle.* Shooting down at coral will yield the same unfavorable results as shooting down at fish, so be sure to descend adequately. Additionally, you should avoid shooting directly at the face of a coral wall or reef. The produces a frame that is just one massive wall of coral. You want negative space in your composition of reef scenes—some water above or alongside your coral scene and/or some sandy bottom should be in view to provide a context.

*Think About Distance and Angle of View.* Don't get too ambitious when you photograph coral. Remember your universe (at least if you want it to be in color!) exists from the closest point your lens will focus out to about five feet. Also, keep in mind that your lens has a limited angle of view. If you want a great amount of the coral reef in your scene, you may need a wider angle lens. If you do not have such a lens, then be less ambitious and shoot a segment of the reef offered to you.

*Keep it Simple.* Don't include too many elements in your composition. This results in a very busy-looking image that confuses viewers because they do not know what the primary subject of the image is. As described previously, my favorite reef scene is a simple picture of a purple sea fan. An orange elephant ear sponge is a secondary subject but mainly there to add a contrast. The negative space, the water, helps separate the subject and makes it easy for viewers to identify the subject of the image. It doesn't hurt that the color of the negative space is blue, which coordinates well with other colors in the image. ( *Note:* Coral also makes an excellent subject to shoot in the portrait mode, which may help you isolate a section of the reef for a simple composition.)

*Consider Snell's Window.* You can choose to build on that composition by including Snell's window, the surface of the water that you can see. This is named for a 17th-century mathematician named Snell. You can Google it to study the science if you're interested—for my part, I'm just happy to be aware of its compositional possibilities. (It's also a fancy term to toss out when you're "techie talking"!) If you shoot at a sufficiently upward angle, you will include Snell's window. ( *Note:* If you choose to compose by shooting upward at your coral you will also empower it. It will appear bold and add an element of drama.)

You might also include the rays of the sun (if those are penetrating the water column). To capture the sun's rays effectively, you may need to consider increasing your shutter speed.

*Watch the Colors.* To me the subject of a reef scene is not necessarily "what" it is that I am photographing, but often the color of it or colors in it. The colors themselves are the subjects, as are the shape of the reef's structure and its texture. ( *Note:* Alternately, you could try creating a silhouette of the reef to focus on its outline.)

Coral is most times, as stated earlier, relegated to the role of being the supporting actor in underwater photography. It does not necessarily have to be so. You can make it the star of your image.

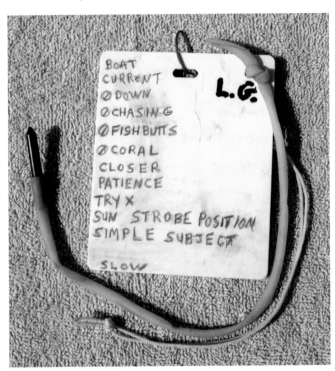

This is the slate that I carry with me on dives when teaching underwater photography. It is a cue card of sorts. This "cue card" reminds us to pay attention to navigation, be mindful of what the ocean may be doing (in terms of the current), and to be mindful of not harming the coral. It also contains reminders about some of the most common errors underwater photographers make in their technique.

# 7. POSTPRODUCTION

There are three key steps in the final representation of an image. Step one is taking the photograph. Step two is developing/processing the photograph. Step three is making a print of the developed/processed photograph. If each step goes smoothly, then a realistic, if not artful, representation of what was witnessed will end up being displayed on the wall. In a perfect and pure world, what was seen by the photographer at the time the photograph was taken will end up being the same thing that is seen later, by the viewer of that photograph.

In film photography, photographers typically do not do their own developing but take their unprocessed film to a lab. Therefore, the development of the photographer's media is, to a large degree, out of their hands; it is in the hands of that developer. The developer can use darkrooms techniques to improve your photograph, adjusting for

Large expances of the reef are best photographed with a lens with a very wide angle of view. Such a lens will enable the photographer to capture the expanse, yet be close enough so colors are not absorbed by the water column.

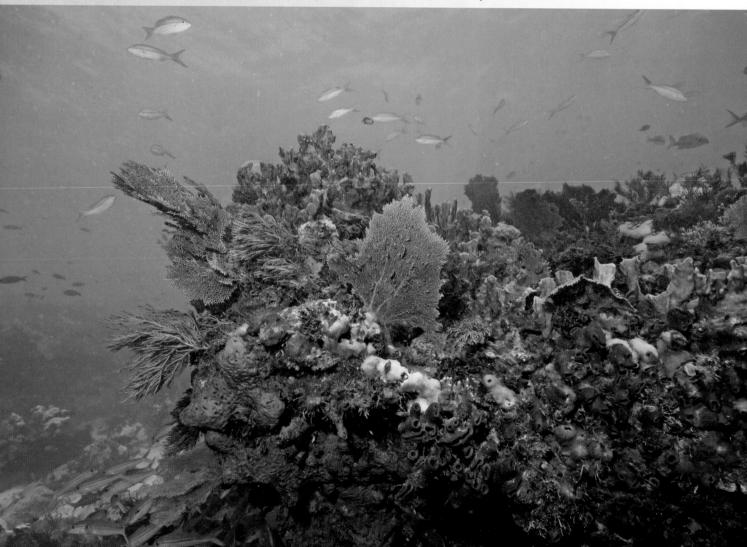

lightness, contrast, or color, for example. Conversely, the developer can ruin your image through errors in the developmental processes. They can also do physical damage to your negatives or slides—or lose them altogether. Clearly, in film photography, care needs to be taken as to the selection of your developer.

In digital photography on the other hand, we—the photographers—are most often the "developers" of our own imagery. We accomplish this using a computer and a photo editing program (like Adobe Photoshop). In addition to enabling us to be our own developers, this equipment also allows us to safely archive our images. To me, this added control is a significant advantage—but one needs to take care to "develop" only what really happened at the time the photograph was taken.

## THE ETHICS OF IMAGING

When it comes to the enhancement and manipulation of photographs, there is ongoing debate in the photographic community about what is acceptable and what is unacceptable. These discussions are mainly philosophical and ethical but can even border on being a determination of legality!

Purists argue that there is no image displayed that has not been enhanced. This is because "enhancement" starts with the choice of film or white balance setting used (these have different biases with respect to lighting conditions, colors, and saturation). Things become more of a gray area, however, when we consider the dramatic changes that can be enacted using image-editing software.

My view is that enhancements that were (or are) generally acceptable in the film lab or darkroom should also be accepted enhancements in the digital darkroom. These should be simple, few, and hard to discern. Correcting for exposure is an example of such an enhancement.

I find unacceptable any "enhancements" that alter what really occurred at the time the photograph was taken. I would refer to these changes as manipulations rather than enhancements. An example of manipulation would be adding a shark to a photograph.

Both enhancement and manipulation can make the photographer appear to be a better photographer than the photographer actually is. However, it can also make people suspicious that all of your great images are the result of enhancements and manipulations rather than your underwater photographic skill and creativity.

## INITIAL WORKFLOW

Yes, this chapter is about the darkroom and all the work that occurs there. However, it is not about how to use all the various tools found in your photo-editing program. Rather it is about the steps I recommend taking in the process of processing your digital images.

**Monitor Calibration.** To begin, make sure your monitor is color-calibrated, so that the colors you see are rendered accurately and will be displayed accurately by other devices. Some monitors come with a color calibration utility, or color-calibration programs can be purchased.

**Develop a Routine.** Working in the digital darkroom is easier and more efficient if you develop a routine. My workflow developed by talking to other photographers. I simply asked them about their workflows and pirated the ideas I felt would work for me. So, what follows is what I do. It will probably vary from what works best for you—but I have no argument with other methods. What's important is that you *have* a system, not so much what it is.

> # I find unacceptable any "enhancements" that alter what really occurred.

*From Camera to Computer.* My workflow begins with getting my images from my camera and onto my computer. The photographs are downloaded into a folder on my computer's hard drive.

*Organizing.* Part of a good workflow is organizing your photographs into folders. Some photographers organize

Elkhorn coral is a very fast-growing coral. Stands of it are most often found and photographed on top of reef structures.

them in dated folders. Others organize by subject. Still others organize by geographic location. Basically, you just need to be able to find your photographs later. You begin the organization by deciding which folder to download the photographs to.

*Backing Up.* Once the images are downloaded, some photographers will immediately back up their images—and leave the images on their camera's memory card until they complete this process. I admit that I do not do either— and that this is at my own peril. My risk in not backing up to another drive or media is that if I have a drive failure my images will be lost. (I've yet to have a drive failure when working on a new folder full of images. Knock on wood!) Instead, I wait and later backup only those images that I want to save. (*Note:* The exception to this is when I am on a vacation trip. Then, I will download the files from my camera onto a computer, copy those files onto a CD or DVD, then delete the images from my card. I will then process these files when I return home.)

*Reviewing the Files.* My next step is to open the folder that contains the image files I just downloaded. I am going to review these images three times.

My first review is just a quick peek to see what I have "in the can." I do not scrutinize each and every shot during this preview. This may take about two seconds per image to do. If I've done my job correctly with my camera, I have more than one shot of each subject. The thought in my mind at this first viewing is to look for images that should be deleted. Giving all your images a quick peek prevents you from falling in love with any one of them before you've had the chance to view all the others. This makes it easier to eliminate images that are unacceptable.

I am now ready to do the second, critical review of my images. I try to be my own worst critic. I evaluate each photograph to determine if it includes the four elements that comprise an acceptable image. At this point, the tool I use is the Delete key. This can be one of the most difficult tools to use, but it should become one of your favorites.

Deleting less-than-acceptable images can help build, or save, your reputation as an underwater photographer! While I do not mind taking a bad photograph (I can learn from it), I am not anxious to display it, either.

This second viewing takes a bit more time, but after my preliminary review it is now easier for me to delete the obviously unacceptable images—those that are out of focus, incorrectly exposed, or poorly composed. During this second viewing I also try to determine which single frame in any series of shots I have of the same subject I want to keep; I delete the others in that series. I keep in mind how I wanted the image to turn out; if I did not succeed, then I should not be saving the photograph. I analyze why I was not successful, and what I could have done differently to be successful, then I use the Delete key tool.

Over the years I have thrown out cardboard boxes full of photographs. As I was going through these boxes, I wondered what compelled me to save them to begin with. Now that I am shooting digital, I am trying to avoid filling my computer's hard drive with images I have no reason to save. Filling my hard drive with less-than-acceptable images makes it difficult for me to later find the acceptable images; it's a haystack in which I am trying to find a needle.

If you are going to save an image, then have a reason (or reasons) to save it. I ask myself whether I will have a use for it before saving it. I ask whether I will have an opportunity to later capture a more acceptable image of the same subject. These questions help me decide whether to keep or delete. I don't keep a bad image because I hope some day there will be a photo-editing program developed that will enable me to turn that bad image into a great image! (*Note:* I will sometimes keep a bad image out of sentiment or because that is the only image I have of that particular subject. Later, however, either the sentiment wanes or I finally capture a better image of that subject.)

Once my second review is done, I am ready for the third pass. It usually takes me a third review to accomplish what I try to do in the second. The end result is I have decided upon which images are my keepers.

If, by this time, you have not gathered a crowd around you in your darkroom, this is a nice time to invite someone to take a look at what you've photographed. This is a time to show and listen, not show and tell. I have found this to be of great help to me in deciding whether to keep an image, or which image of a series to keep.

## EDITING WORKFLOW

The next step in my workflow is to begin my photo editing. This step is sometimes called postprocessing and is analogous to the development process in film photography.

The first step is to open my image in my photo-editing program. (I use Adobe products and Windows.)

If I have done a flawless job underwater with my camera, I will find that there are no images that need any further processing. More likely, however, I'll identify some

images that I believe would be candidates for further tweaking with the tools in my photo editing software.

**Duplicate the File.** Before I begin work on an image, I create a duplicate copy of it. Once the duplicate is made, I close the original image file and it is now saved—safely residing back in the folder I opened it from, and safe from my edits!

If I am working with a JPEG file format, I will next convert the file to a lossless file format. (JPEGs use a lossy compression algorithm that discards data each time the image is opened, edited, and closed.) I convert the file to a TIFF, then make a duplicate copy of the TIFF file. I then close the first TIFF; it now resides alongside the original JPEG file in the folder.

**Cropping.** My first decision in the photo editing process is to decide whether to crop the image. There are two reasons to crop. One reason is to crop for a more pleasing composition and the other reason is to crop for printing purposes. Because cropping out data reduces the file dimensions, it can limit your print size. Therefore, I am very reluctant to crop for composition and try to compose well with my camera—as much as possible, I crop for composition using my fins. (That's the technique thing, again.)

The second reason to crop is for a given print size. This can be done in your image-editing software, but I don't want to fill up my drive with all those different "cropped for a given print size" files. Fortunately, I've developed a wonderful relationship with my printer and rely totally on their expertise to crop for the print size I want made. I do not make my own prints, so this is a very important relationship to develop and maintain.

**Basic Enhancements.** The next step is to see whether any adjustments to exposure, color balance, saturation, hue, contrast, or brightness will benefit my image. This is when and where any enhancement is done. It is also where the fun begins!

Most photo-editing programs have some automated tool that can be applied simply by selecting them from a menu or tool bar. These can beneficially enhance the image, but I usually get better results without them. Working in Photoshop, I prefer to begin my investigation into whether any enhancement edits will benefit my image by using an image adjustment tool called Levels. This is where I can check and adjust for exposure using a composite his-

togram for the image or individual histograms for the color channels (red, green, and blue) . Whatever tool I use, if I am unhappy with the result, I can undo it. (*Note:* Other tools I sometimes experiment with are: curves, color balance, saturation, hue, and brightness/contrast. I use the word "experiment" because some of the process is just that: try the tool and see what the result is. In trying these tools, you begin to learn what the tool does and whether it will help with enhancing an image in the future.)

At this point you are working with a good image and trying to make it better. The data was already there—and you will sometimes be surprised at how, with a little bit of tweaking, you can bring this data out. Suddenly the image will really pop!

**Save Along the Way.** When I find myself making many and/or time-consuming edits to an image, I include another step in my editing: I "save along the way." Photo-editing programs can consume your computer's memory

and processing power. Making lots of edits taxes these resources and can result in the system locking up, shutting down, or manifesting some other issue. Edits completed up to that point in time are often lost—and you end up having to start all over again! Because of this possibility, I save my work periodically by making a duplicate copy and

Pictured here are two flamingo tongues. These are most aften found on the common sea fans and sea rods. They are small—about thumbnail-sized—and, therefore, are subjects for macrophotography.

closing the file I had been working on. Then I continue my edits on the copy. I delete those extra copies when I am finished with my edits.

**Be Subtle.** When making my enhancing edits, I keep them subtle. It should not be obvious that edits were made. This is not because I am trying to be sneaky or dishonest; rather, the issue is that obvious edits can create something unrealistic—like a shade of blue that does not exist in the water column. Such an edit may look "artsy," but it takes away from the reality of what was actually photographed. Overediting can produce grotesque results. I suggest looking at your digital darkroom as if you were in

FACING PAGE—A school of forage fish, sometimes called silversides or minnows, is pictured here. For a sense of scale, a diver's face was included in the composition.

a film-era darkroom and are only "touching up" your photograph. The darkroom is not a beauty parlor, nor is it a cosmetic surgery facility.

**Address Imperfections.** Once I am finished with these types of enhancing edits, I look for imperfections like backscatter. I should have to *look* for it; if I had an image with grossly obvious backscatter, it should have been deleted on my second viewing! In Photoshop, I use the Clone Stamp tool to rid the image of any backscatter I

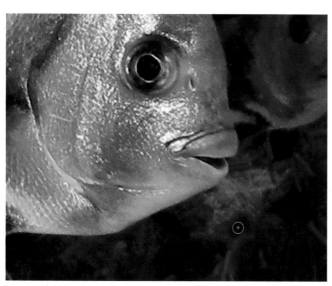

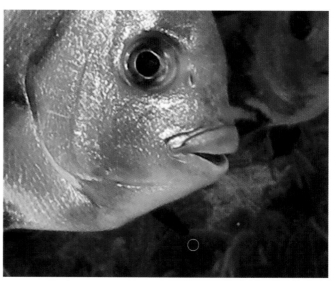

LEFT—The idea behind the use of the Clone Stamp tool is to remove some imperfection in an otherwise nice image. To learn its use, I suggest practicing on an unacceptable image like this! Here, I have identified an imperfection and moved my brush (indicated by the circular cursor) over it. RIGHT—With the Clone Stamp tool selected, I have moved my brush over the area that I want to clone from. I press and hold Alt/Opt (PC/Mac), then click with my mouse (left button) to load the data into my brush.

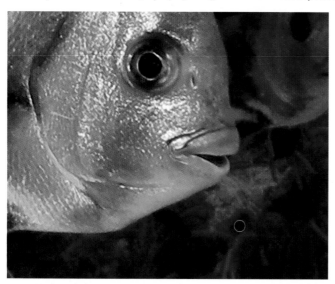

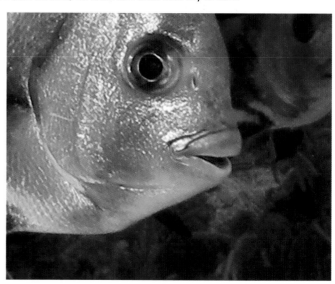

LEFT—I next slide my cursor over the area I want concealed with the data I just selected (the problem area) and click with my mouse (left button). RIGHT—Here is the result—and the objectionable spot is gone!

find. To do this, I zoom in on my image and select a soft, round brush. This allows me to clone "clean" data from a nearby area of the image over the offending spot of backscatter. (*Note:* The Clone Stamp tool is great for little touchups. It can also work for remedying small amounts of lens vignetting or to remove some small object that jumped into the frame as the photo was being taken.)

**Sharpening.** The next step in my editing is deciding whether I should sharpen my image. (*Note:* Sharpening will not help repair an image that is not in focus.) In Adobe Photoshop, the most commonly used tool for sharpening is the Unsharp Mask filter. However, the sharpening settings you should use depend upon the intended final use of the image (on-line sharing, printing, etc.)—and each image may require different settings. Because of this, I leave it to my printer to decide whether or not my image will benefit from sharpening.

## BACKING UP

The final step is backing up my imagery. I back up the original JPEG as well, the copy of the TIFF version that was made from it, and my finished version. I copy these onto an external hard drive. My more precious images are also copied onto a CD-R or DVD.

## LESS IS MORE

Ultimately you will settle on a workflow system and set of tools that is right for you. My view, however, is that the fewer tools you "need" the better. To me, needing fewer tools in postproduction indicates that you are doing something very right underwater with your camera.

The huge amount of time that can potentially be spent in the digital darkroom is probably a good motivator to take a good photograph to begin with. In fact, one way to measure your progress is by how much or little time you spend "having" to do edits. Another way to measure progress is by considering the number of your photographs you find you are editing.

Pederson cleaner shrimp are many times found with corkscrew anenomes. Here, three Pedersons are congregated and make their living by offering cleaning services to fish in need.

Underwater photography got its start, as we "regular guys" know it today, with Jacques Cousteau. I realize this is arguable, because he certainly was not the first underwater photographer (and some would dispute that he was an underwater photographer at all). However, he was an early promoter of underwater photography, using the Calypso Phot amphibious camera, which was designed by Jean De Wouters in 1957. In the early 1960s, Nikon began producing this camera (redesigned from its original form) and marketing the Calypso under the brand name Nikonos. This amphibious camera later became known as the Nikonos 1. Later models of the Nikonos camera system came into the market and were adopted by most all of the professional underwater photographers—and, of course, later by us "regular guys."

Naturally, many events that were pertinent to underwater photography occurred prior to this. One of them was during the 1930s, when Dr. Hans Haas designed a waterproof camera housing for a Zeiss 16mm movie camera. In the late 1940s, Haas (along with a German company) also designed and constructed a waterproof housing for the Rollei 6x6cm still picture camera. This was known as the Rolleimarin housing. Later, a watertight housing was made for the Hasselblad SLR camera. (Hans Haas and his wife, Lotte, were also early contributors to underwater photography and cinema photography.)

In recent years, underwater photographer, photography educator, and author Jim Church also played a very significant role in the development and popularization of underwater photography. He was a presence in the endeavor for thirty-five years, until he passed on several years ago.

There are others who came before and after those I made mention of above. Many who came later, including

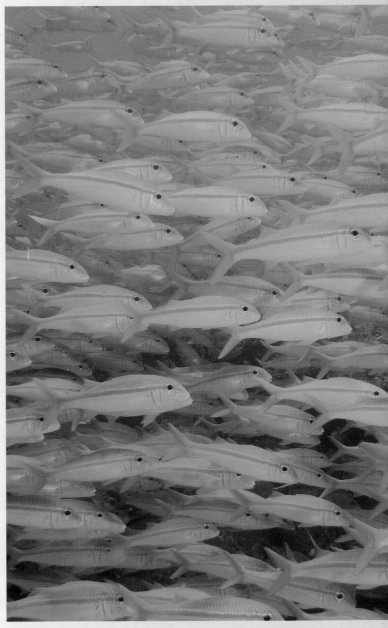

A large, densely packed school of goatfish photographed at Snapper Ledge off of Key Largo, Florida.

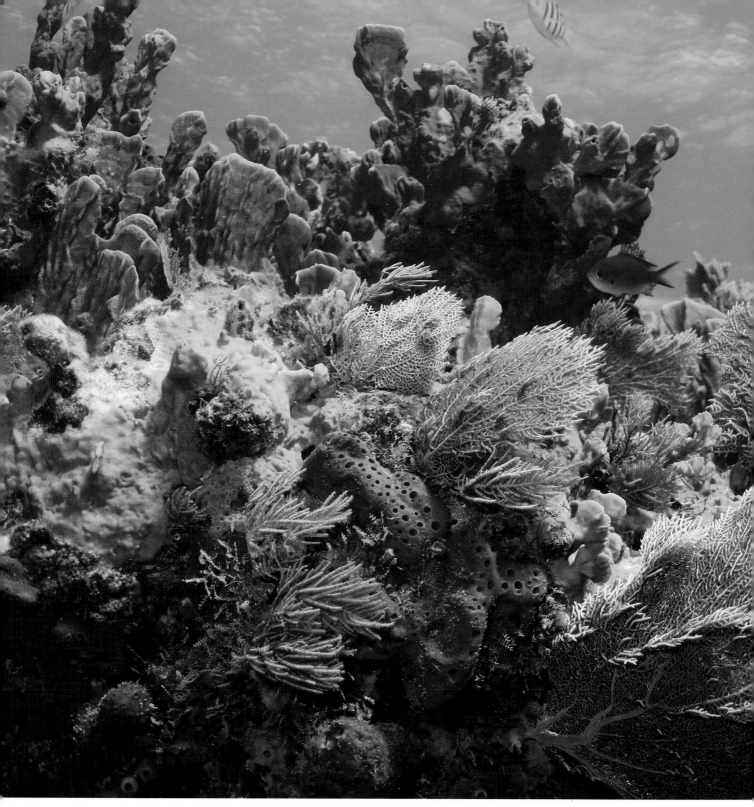

A short study of the coral reef. There are almost countless numbers of corals and sponges within the few square yards of space photographed here.

myself, began their own underwater photography based in part on the contributions of the aforementioned. When I think of these individuals, and others, and all of their contributions to underwater photography, I am humbled.

As I transitioned into the world of digital photography, I struggled—until I had a thought that almost overwhelmed me. I was thinking about the equipment used by all those people who inspired me—Jacques Cousteau, Haas, Jim Church, and others. By today's standards, it was not very fancy stuff, but in the right hands it made wonderful imagery.

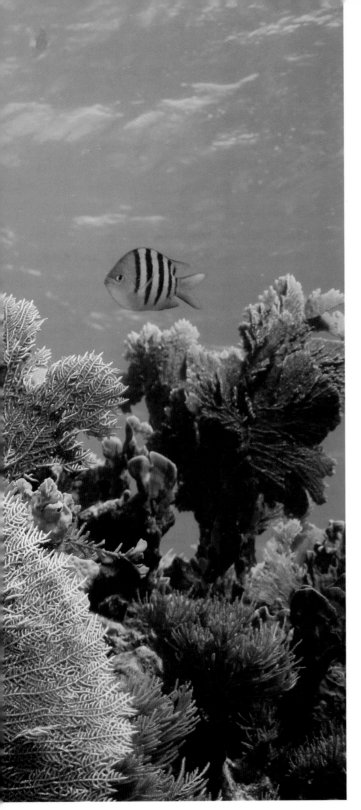

an ISO still an ISO. A strobe was still a strobe. The "technique" part of underwater photography had not changed; my struggle with this digital camera was that I was trying to outthink its technology!

Since then I've no longer struggled with digital underwater photography (well, at least no more than I did when I was when using a film camera!). Then, as now, great underwater images are made by selecting the correct lens for the subject and the right settings to make the exposure. The rest is all about technique, whether the camera is film, or, the latest state of the art in digital!

There exists a "stratification" of underwater photographers. There are around two dozen "top drawer" underwater photographers with names that are well-known within the diving community. There is no question that these individuals are great shooters! They live around the world and travel the world's oceans on assignment. Moving further into this stratification, there are probably several hundred people like myself: good (sometimes great)

A giant head of brain coral, with encrusting orange elephant ear sponge, is discovered just under the dive boat.

That's when I realized that all I wanted of this new-fangled digital contraption was for it to perform like my good old film camera did! I was happy with those images, so if I could get the digital camera to perform the same way, I should also be happy with the images it produced. While the technology had changed from film to digital, an f-stop was still an f-stop, shutter speed still a shutter speed, and

shooters who spend a lot of time teaching underwater photography. We, too, live all around the world and mainly in dive resort areas of the world. (We are often referred to as "photo pros.") Deeper into the stratification, there are countless numbers of very good—if not great—professional and non-professional shooters all over the world who do not have the fame or notoriety of the aforementioned two dozen or the desire to teach underwater photography to others.

So why am I telling you this? Well, it makes it clear that there are lots of ways to become a good—if not a great—underwater photographer. Whoever you are, and whatever your objectives may be (whether you want to be one of that elite two dozen or just put up better images from your dive trip on your refrigerator) you can do it. With any camera, you can implement the techniques we've looked at throughout this book and create images you'll be proud to share. It's just that simple!

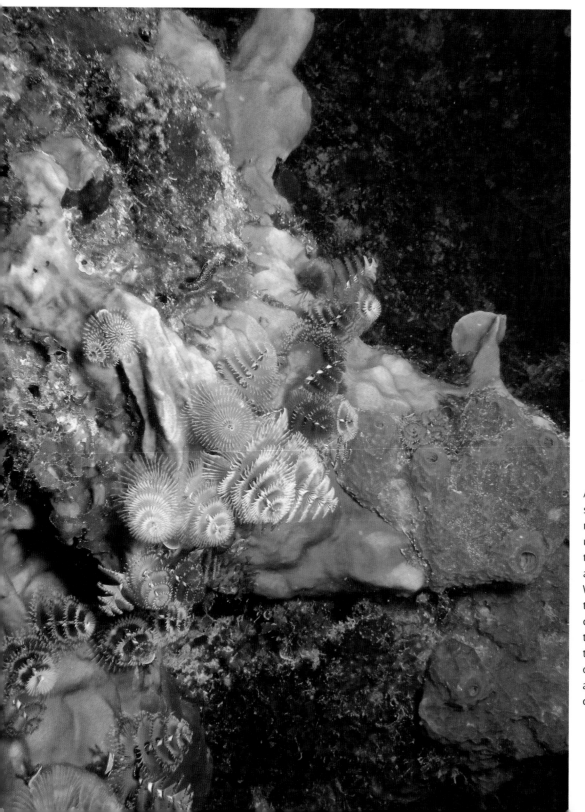

A macro photograph of a stand of one-inch Christmas tree worms. Preyed upon by many reef fish, these worms are skittish and sensitive to vibration. When spooked, they retreat into bores of the coral they live on. A photographer can wait when that happens; they will often reappear and provide a second chance to get the capture.

# RESOURCES

## ONLINE

**www.postersize-it.com**—Printers of fine-quality photographic enlargements to poster sizes.

**www.ikelite.com**—Makers of quality underwater strobes and housings.

**www.wetpixels.com**—Informative underwater photography web site.

**www.canon.com**—Digital cameras and photography equipment.

**www.nikon.com**—Digital cameras and photography equipment.

**www.olympus.com**—Digital cameras and photography equipment.

**www.adobe.com**—Maker of photo and graphics editing applications.

**www.dpreview.com**—Resource for digital cameras and lenses.

**www.sealife.com**—Makers of underwater cameras, housings, strobes, lenses, and accessories.

**www.sea&sea.com**—Makers of underwater cameras, housings, strobes, lenses, and accessories.

**www.hansdejager.com**—Hans Dejager's online gallery showcases vision.

**www.stephenfrink.com**—Informative web site of renowned underwater photographer Stephen Frink.

**www.daveread.com**—Well-conceived educational site on underwater photography.

**www.fotoquote.com**—Software used to price imagery.

**www.reefphoto.com**—An underwater photography equipment specialty store, Ft. Lauderdale, FL.

**www.outdoorphotographer.com**—Online photography magazine.

**www.tomstackphoto.com**—Web site of renowned underwater photographer, Tom Stack.

## BOOKS

Church, Jim. *Jim Church's Essential Guide to Composition: A Simplified Approach to Taking Better Underwater Pictures* (Aqua Quest Publications, Inc.; 1998).

Church, Jim. *Jim Church's Essential Guide to Nikonos Systems* (Aqua Quest Publications, Inc.; 1994).

Drafahl, Jack and Sue. *Digital Imaging for the Underwater Photographer* (Amherst Media; 2005).

Hall, Howard and Skerry, Brian. *Successful Underwater Photography* (Amphoto; 2002).

Kelby, Scott. The Adobe Photoshop CS4 Book for Digital Photographers (New Riders Press; 2009).

Mount, Tom. *The Complete Guide to Underwater Modeling.* (Sea-Mount Publishing Co.; 1983).

Professional Association of Diving Instructors (PADI). *PADI Underwater Photographer* (PADI, 1997).

Writers Digest Books. *Photographer's Market* (annually published book listing various means to market images and providing a list of stock photography agencies).

# INDEX

## THE BEST OF
## NATURE PHOTOGRAPHY

*Jenni Bidner and Meleda Wegner*

Ever wondered how legendary nature photographers like Jim Zuckerman and John Sexton create their images? Follow in their footsteps as top photographers capture the beauty and drama of nature on film. $29.95 list, 8.5x11, 128p, 150 color photos, order no. 1744.

## THE ART OF
## PHOTOGRAPHING WATER

*Cub Kahn*

Learn to capture the dazzling interplay of light and water with this beautiful, compelling, and comprehensive book. Packed with practical information you can use right away to improve your images! $29.95 list, 8.5x11, 128p, 70 color photos, order no. 1724.

## DIGITAL IMAGING
## FOR THE UNDERWATER
## PHOTOGRAPHER, 2nd Ed.

*Jack and Sue Drafahl*

This book will teach readers how to improve their underwater images with digital image-enhancement techniques. This book covers all the bases—from color balancing your monitor, to scanning, to output and storage. $39.95 list, 6x9, 224p, 240 color photos, order no. 1727.

## THE MASTER GUIDE FOR
## WILDLIFE PHOTOGRAPHERS

*Bill Silliker, Jr.*

Discover how photographers can employ the techniques used by hunters to call, track, and approach animal subjects. Includes safety tips for wildlife photo shoots. $29.95 list, 8.5x11, 128p, 100 color photos, index, order no. 1768.

## HEAVENLY BODIES
THE PHOTOGRAPHER'S GUIDE TO ASTROPHOTOGRAPHY

*Bert P. Krages, Esq.*

Learn to capture the beauty of the night sky with a 35mm camera. Tracking and telescope techniques are also covered. $29.95 list, 8.5x11, 128p, 100 color photos, index, order no. 1769.

## THE DIGITAL DARKROOM
## GUIDE WITH ADOBE®
## PHOTOSHOP®

*Maurice Hamilton*

Bring the skills and control of the photographic darkroom to your desktop with this complete manual. $29.95 list, 8.5x11, 128p, 140 color images, index, order no. 1775.

## THE PRACTICAL GUIDE
## TO DIGITAL IMAGING

*Michelle Perkins*

This book takes the mystery (and intimidation!) out of digital imaging. Short, simple lessons make it easy to master all the terms and techniques. $29.95 list, 8.5x11, 128p, 150 color images, index, order no. 1799.

## DIGITAL LANDSCAPE
## PHOTOGRAPHY STEP BY STEP

*Michelle Perkins*

Using a digital camera makes it fun to learn landscape photography. Short, easy lessons ensure rapid learning and success! $17.95 list, 9x9, 112p, 120 color images, index, order no. 1800.

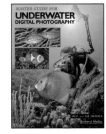

MASTER GUIDE FOR
## UNDERWATER DIGITAL
## PHOTOGRAPHY

*Jack and Sue Drafahl*

Make the most of digital! Jack and Sue Drafahl take you from equipment selection to underwater shooting techniques. $34.95 list, 8.5x11, 128p, 250 color images, index, order no. 1807.

## BLACK & WHITE
## PHOTOGRAPHY
TECHNIQUES WITH ADOBE® PHOTOSHOP®

*Maurice Hamilton*

Become a master of the black & white digital darkroom! Covers all the skills required to perfect your black & white images and produce dazzling fine-art prints. $34.95 list, 8.5x11, 128p, 150 color/b&w images, index, order no. 1813.

## MASTER COMPOSITION
### GUIDE FOR DIGITAL PHOTOGRAPHERS

*Ernst Wildi*

Composition can truly make or break an image. Master photographer Ernst Wildi shows you how to analyze your scene or subject and produce the best-possible image. $34.95 list, 8.5x11, 128p, 150 color photos, index, order no. 1817.

## THE PHOTOGRAPHER'S GUIDE TO
### COLOR MANAGEMENT
#### PROFESSIONAL TECHNIQUES FOR CONSISTENT RESULTS

*Phil Nelson*

Learn how to keep color consistent from device to device, ensuring greater efficiency and more accurate results. $34.95 list, 8.5x11, 128p, 175 color photos, index, order no. 1838.

### RANGEFINDER'S PROFESSIONAL PHOTOGRAPHY

*edited by Bill Hurter*

Editor Bill Hurter shares over one hundred "recipes" from *Rangefinder's* popular cookbook series, showing you how to shoot, pose, light, and edit fabulous images. $34.95 list, 8.5x11, 128p, 150 color photos, index, order no. 1828.

## ADOBE® PHOTOSHOP®
### FOR UNDERWATER PHOTOGRAPHERS

*Jack and Sue Drafahl*

In this sequel to *Digital Imaging for the Underwater Photographer,* Jack and Sue Drafahl show you advanced techniques for solving a wide range of image problems that are unique to underwater photography. $39.95 list, 6x9, 224p, 100 color photos, 120 screen shots, index, order no. 1825.

## MASTER GUIDE FOR
### UNDERWATER DIGITAL PHOTOGRAPHY

*Jack and Sue Drafahl*

Make the most of digital! Jack and Sue Drafahl take you from equipment selection to underwater shooting techniques. $34.95 list, 8.5x11, 128p, 250 color images, index, order no. 1807.

## FILM & DIGITAL TECHNIQUES FOR
### ZONE SYSTEM PHOTOGRAPHY

*Dr. Glenn Rand*

Learn a systematic approach to achieving perfect exposure, developing or digitally processing your work, and printing images that suit your creative vision. $34.95 list, 8.5x11, 128p, 125 b&w and color images, index, order no. 1861.

## BIG BUCKS SELLING YOUR
### PHOTOGRAPHY, 4th Ed.

*Cliff Hollenbeck*

Build a new business or revitalize an existing one with the comprehensive tips in this popular book. Includes twenty forms you can use for invoicing clients, collections, follow-ups, and more. $34.95 list, 8.5x11, 144p, resources, business forms, order no. 1856.

## ILLUSTRATED DICTIONARY OF PHOTOGRAPHY

*Barbara A. Lynch-Johnt & Michelle Perkins*

Gain insight into camera and lighting equipment, accessories, technological advances, film and historic processes, famous photographers, artistic movements, and more with the concise descriptions in this illustrated book. $34.95 list, 8.5x11, 144p, 150 color images, order no. 1857.

## BUTTERFLY PHOTOGRAPHER'S HANDBOOK

*William B. Folsom*

Learn how to locate butterflies, approach without disturbing them, and capture spectacular, detailed images. $34.95 list, 8.5x11, 128p, 175 color images, index, order no. 1877.